T0034609

THROUGH THE RUINS

THROUGH THE RUINS

Talks on Human Rights and the Arts 1

Edited by Fawz Kabra

To Adam, Ali, Carol, Garrett, Hattie, Iris, Isabella, Majd, Margarita, Nour, Oscar, and Pavel, our first cohort of graduate students.

© 2023 by the OSUN Center for Human Rights and the Arts
at Bard College. *Through the Ruins* is licensed under a Creative
Commons Attribution 4.0 International License.

Published by OSUN Center for Human Rights & the Arts at
Bard College, 30 Campus Road, Annandale-on-Hudson, NY 12504;
and Natus Books, 120 Station Hill Road, Barrytown, NY 12507

This publication was produced in collaboration with the
Open Society University Network and supported by a grant from the
Open Society Foundations.

Talks on Human Rights & the Arts is curated by Tania El Khoury,
Thomas Keenan, and Gideon Lester

Production and editorial assistance by Polina Malikin

Cover photo by Cassils, *Cuts: A Traditional Sculpture: Time Lapse*, 2011

Book design by Will Brady

Cover illustration by Haitham Haddad

ISBN: 9781581772241

Library of Congress Control Number: 2022951982

Printed in the United States of America

CONTENTS

LAND ACKNOWLEDGMENT

For Bard College,
Annandale-on-Hudson, NY

In the spirit of truth and equity, it is with gratitude and humility that we acknowledge that the OSUN Center for Human Rights and the Arts at Bard College resides on the sacred homelands of the Munsee and Muhheaconneok people, who are the original stewards of this land. Today, due to forced removal, the community resides in Northeast Wisconsin and is known as the Stockbridge-Munsee Community. We honor and pay respect to their ancestors past and present, as well as to future generations, and we recognize their continuing presence in their homelands. We understand that our acknowledgment requires those of us who are settlers to recognize our own place in and responsibilities toward addressing inequity, and that this ongoing and challenging work requires that we commit to real engagement with the Munsee and Mohican communities to build an inclusive and equitable space for all.

FOREWORD

In the past two decades, artists and art critics have been making claims and debating about what makes art a political practice. Some wrote how-to books arguing that it is art that connects, homogenizes, and builds micro-utopias. Others counterargued that politics happens through antagonistic, spectacular, and shocking acts. Authorship in art was demonized, then celebrated, then demonized again. Meanwhile governments, cities, and urban developers were busy employing art and artists as would-be relief for societal problems. Instrumentalized art is meant to beautify, encourage an entrepreneurial class of art producers and consumers, and smooth over deeply rooted inequalities. In more cynical cases, it functions as advocacy for neoliberal politics and war-washing. Art engages with politics even when it denies doing so. Artists become activists and activists become artists more frequently than the art world and the human rights advocacy world notice. The most interesting examples of this intertwining are not often registered in Western art history writing.

Today, it remains rare to find publications in which we hear directly from those on the forefront of a critical yet grounded art and activism practice. The Talks on Human Rights & the Arts Series makes space for inspiring artists, activists, and scholars from around the globe to discuss their thoughts and processes in their own words. They do so not to offer a singular recipe for how this intersection manifests or should work, nor do they present themselves and their collaborators as saviors of their communities, the art world, or the field of human rights. Rather, they share research, experiment with mediums, and produce alternative knowledge and dissident aesthetics. Their work is often multidimensional and always multidisciplinary.

Through the Ruins is based on live presentations given in spring 2021. Each contribution has its own flow, style, and delivery. The book offers a documentation of ephemeral events that took place virtually with presenters based on many continents and in many time zones. These are Faustin Linyekula, The White Pube, Cassils, Emily Johnson, Border Forensics, Ashmina Ranjit, Mark Sealy, and Hamed Sinno. As the first speakers in our series, this group of choreographers, art critics, live artists, scholars, and musicians guided our thoughts during the founding period of the OSUN Center for Human Rights & the Arts at Bard College (CHRA).

CHRA was founded by artists and scholars with the common goal of enriching, researching, and reimagining the conversation on the political potential of art within a critical human rights discourse. Through its public programming and international M.A. program, CHRA invites artists and activists to intertwine their practices and expand them beyond the professionalization of human rights activism in the NGO-industrial complex and the institutionalization of contemporary art in galleries and museums.

The Center is a project of the Open Society University Network (OSUN), a group of more than forty educational institutions that share a commitment to addressing global challenges collaboratively. These talks were moderated by colleagues from across OSUN. Our guest editor, curator Fawz Kabra, assembled excerpts from the public conversations that followed these talks to create a book that is an accessible resource for all.

The title *Through the Ruins* is taken from Faustin Linyekula's talk delivered from Congo, during the Center's very first public event. Linyekula spoke to us about the need and responsibility of taking a journey through personal and ancestral ruins in order to imagine other possibilities. This volume offers a reflection on the debris we have all inherited as well as a call to collectively act on our responsibility to reimagine the world and our place in it.

—Tania El Khoury
Director, CHRA

EDITOR'S NOTE

In 2021, the OSUN Center for Human Rights and the Arts (CHRA) at Bard College, New York, presented its first series of talks by artists and activists from around the world. This volume captures the urgent contemporary issues where art and activism meet to respond to social struggles by pushing the limits of artistic production. Collectively, these talks, passages of which were edited for clarity, offer a way to reimagine spaces for creative and active criticality.

The title of this volume, *Through the Ruins*, is inspired by the title of Faustin Linyekula's talk, "Of Ruins and Responsibility." In their own ways, all the presenters are in fact moving through inherited ruins, each proposing something generative and transformative. Their projects, experiments, and actions are driven by a collective desire to shapeshift and maneuver in the spaces between. They ask how we can work in between the mechanisms of oppression and create new imaginaries where renewed language and perspective grow out of our interwoven journeys.

Today we are confronted with images of land masses that are burning, drying out, shrinking, flooding, or becoming expansive fields of surveillance, open-air prisons, and human rights crises. According to Faustin Linyekula, the lands passed on to us are the "ruins we have inherited." Speaking from the DR Congo, the dancer, choreographer, storyteller, and social activist contemplates what it means to assume responsibility for these ruins, whatever their condition, and to tell one's stories from home, not from exile, while inventing new forms with which to tell these stories.

These new forms of storytelling are part of a larger discourse, meeting at the intersection of art and human rights, that has shaped essential and thriving artistic practices that are multibranched and move

audiences, communities, and state actors into thoughtful action and change. Calling in from London, *The White Pube*'s Zarina Muhammad presents "[ideas for a new art world]." Through their critical writing, the art and gaming critics Muhammad and collaborator Gabrielle de la Puente challenge the art world's lack of representation and accessibility, redefining what is considered worthy of aesthetic attention; their website has become a space to call out the "slap on the wrist attitude of white cultures, always a teaching moment."

Cassils also addresses the politics and limits of representation. Their practice in live performance, film, sound, sculpture, and photography underscores the fact that all gender is a social construct and that "visibility is a trap." Cassils considers subjectivity and the representation of compliant and vetted trans identity. Emily Johnson, activist and artist of Yup'ik descent, poetically reveals a methodology grounded in the idea that "overflow is resonance ... moving in the in-between, in-the-collective." Johnson visualizes a sensorial practice concerned with the body, its present and future cultural history, and its relationship to the earth.

Open bodies of land and water also have resonance, and Charles Heller and Lorenzo Pezzani, of Border Forensics, have visualized state ocean control and border violence that create conditions of invisibility for migrant boat crossings. Heller and Pezzani's work contests border management and policies that continue their violence on the bodies they have illegalized, and their research has been used by refugees and activists to challenge border discrimination imposed by the European Union.

In "Politics of Being," women, their stigmatized bodies, and statelessness are at the center of Ashmina Ranjit's practice as a performance artist and activist in Nepal. Ranjit's work illuminates the power of collaboration and political engagement to call upon the people to reconsider injustice, amid a land battling anticolonial laws and reconciling with histories of colonization. Ranjit argues for a collaborative "artivist" practice, where art and the politics of identity meet and have a power and potential that leads to new freedoms.

"Decolonizing the camera" is at the center of Mark Sealy's curatorial work, which unearths colonialism's deprivation of people's identity, the robbery of their land, and the active perpetuation of this dehumanizing

system and ideology. The activist, curator, and photographer founded Autograph, the agency of black photographers in the UK. Through his work, Sealy seeks to reveal the "cultural coding" in photography and how the medium has influenced racial representations.

Closing the first volume of *Talks on Human Rights and the Arts*, "Queerness in/as Metaphor" by Hamed Sinno, lead singer of the Lebanese alternative rock band Mashrou' Leila, explores the sincerity of symbolism in the band's music. Sinno discusses past experiences and shares the band's lyrics, which seek to liberate the individual from the limits of representation, words, and their meanings.

Hovering somewhere in the queer, in the in-between, these artists and activists work from within these spaces to dismantle oppressive ideologies and reveal unreconciled histories that haunt the present. They present their own counterimages and create work that undermines oppressive narratives as they construct new potentials in contemporary practices at the intersection of art and human rights.

—Fawz Kabra

FAUSTIN LINYEKULA

OF RUINS AND RESPONSIBILITY

Friday, March 12, 2021
Faustin Linyekula, Kisangani,
Democratic Republic of the Congo

Moderator
Gideon Lester, Senior Curator, CHRA;
Artistic Director and Chief Executive,
Fisher Center at Bard

Photo by Bea Borgers

INTRODUCTION

Gideon Lester

Faustin Linyekula is a dancer, choreographer, storyteller, and social activist. He lives and works in Kisangani, in the northeast of the Democratic Republic of Congo. There, he directs a program called Studios Kabako, dedicated to dance, theater, music, film, education, and social justice and infrastructure programs. As an artist and performer, Linyekula is a kind of embodied historian. He makes performances that hold a living archive of stories and memories. His dancing body remembers histories — histories unwritten, forgotten, or erased, histories of loss and belonging, unity and rupture that tell stories of life in the region we currently call the Democratic Republic of Congo from both pre- and postcolonial times.

The performances that Linyekula and his collaborators create in Kisangani are commissioned by art centers and festivals around the globe, and in normal times Linyekula spends much of the year on the road. He has been a guest choreographer for leading ballet companies in Europe and an associate artist for the Holland Festival, where he co-curated the 2019 edition with the artist William Kentridge. He has won numerous prizes and awards, including the Medal of Merit of the city of Lisbon and the first Soros Arts Fellowship in 2018.

At first glance, there seem to be two parts to Linyekula's practice: his embedded work with Studios Kabako in Kisangani, and his international touring life. In reality, they are all one, united in an expansive, generous, and generative world view and lifework. Linyekula directs the

proceeds from his international career to fund social and artistic projects in Kisangani, a city devastated by decades of political violence. Studios Kabako supports public works that the government of the DRC does not, including programs in education and environmental sustainability, developing a new drinking-water system for the Lubunga district on the south bank of the Congo River, running and operating the first music recording studios in the east of the country, and training a new generation of Congolese artists in performance, music, and film. Linyekula describes these interventions as urban acupuncture. He says, "Our challenge is to speak to the city from its most fragile part."

OF RUINS AND RESPONSIBILITY

Faustin Linyekula

"How will I walk to myself
To my people
With blood on fire
And my history in ruins?"
—Adonis

Hello everyone.
From here, I should say good evening.
Good morning, or good afternoon, and good evening, whatever it may
 be for you.
My name is Faustin Linyekula. I am known as a choreographer, as a
 dancer,
But I like introducing myself as a storyteller.
From the territory we know as the Democratic Republic of Congo.
In his book called *Congo*, the French writer Éric Vuillard writes:
"The Congo does not exist. There is only a great river and the forest."

It's probably because the Congo doesn't exist that I am so obsessed with it.

It is like trying to dig through a void,

Through the forest,

Through the mighty river Congo.

The Congo does not exist. There is only a river and a forest.

To paraphrase the writer Sony Lab'ou Tansi from Brazzaville in Congo,
"When you look at the Congo, you'll see that everything has collapsed.
Even the ground itself has collapsed."
But when I'm here, even in this Congo that does not exist, with only a
 forest and the river,
I know one thing for sure, which is that the people are still here.
And because the people are still here,
All the work is about trying, just trying,
To give a face, to give a name.

I say that what I inherited from my fathers is a pile of ruins.
That is what my country is, a pile of ruins.
I could point fingers.

I could go as far back as King Leopold II,

When the country was invented somewhere in Berlin during the Berlin
 Conference,

When Europeans came together to carve and share Africa, like a big
 cake.

And I could talk of the original sin of greed and violence

That annihilated millions of lives on this land

Because they wanted to get rubber and ivory.

I could point fingers at decades of dictatorship and corruption and
 predation.

But at the end of the day, I think the most important question for me is,

What can I do about these ruins?

So that the story shifts from one of desperation,

Where we say, "Congo does not exist,"

To become one of possibilities, because the people are still here.

Another image would be that my country is a broken circle.

The circle is so important

Because when we want to dance, we make a circle.

There is a whole symbolism to this.

It's like the community coming together,

Side by side, like brothers and sisters.

Energy is circulating,

What goes out of my right shoulder will come back through the left,

We are together in solidarity.

But the Congo is not a circle.

Had it been a circle, we would not be killing each other

The way we have been doing for decades.

The Congo, like anywhere in the world, is not a circle.

Once I've said that, the question then is, what can I do about this circle?

My work becomes like an attempt
To create a possibility for a circle to exist,
Even if it is just for a minute.

I'll take my responsibility—

It becomes about responsibility for all the ruins we inherited from our fathers,

All the broken circles—
And say, what is it that
 I can do about it,
At my own scale?

Twenty years ago,
I understood that the kind of stories that were setting me in motion
Were not stories of exile.
I am intellectually very sensitive to the question of exile,
But these were not the stories that were setting me in motion.
When I realized that, in 2001, I decided to come back to my country,
Which seemed a very crazy decision,
Because then, my country was broken into several pieces.
There was civil war,
But civil war that soon became a regional war
With interventions from many foreign and neighboring countries:
Rwanda, Burundi, Uganda, Angola.

Even faraway countries with whom we do not share borders,
Like Chad, Zimbabwe,
They, too, had troops on this land.

It was in this context that I decided to come back home
Simply because I understood that the stories that I needed to tell were
 not from exile.
I had to be here.
So, I came here and realized that there is no art scene waiting for me,
With for instance trained dancers I would work with. No.
Everything had to be built.
I took my responsibility and started a project,
The project we call Studios Kabako.
It is not a company, it is a place,
A place where we come together,
A place where we try things,
A place where we dream together,
A place where we doubt a lot,
But a place where, on some evenings, we find answers, no matter how
 fragile.
But I realized that the studios could not be about physical space.
I realized from the very beginning that the studios were about humans.
Every human being who came to that space was a potential studio,
Because it is about people believing in themselves,
Believing in something in a context where it is so difficult to believe in
 anything,
And asking themselves the same question,
What can I do about this little space that I control?
For a long time, Studios Kabako was essentially about the arts, or the
 artists.
How do we nurture artists?
How do we create a scene where we could be many
Making contemporary dance or contemporary theater work?
And those were the first five years of the existence of the company.
Then, we were based in Kinshasa, the capital of the country.
But after five years, we decided to move from Kinshasa to Kisangani,

Which was another crazy thing to do because my country is extremely
 centralized.
As though anywhere outside of Kinshasa lacks possible life.
To a point where for many civil servants,
Being appointed to a position in Kinshasa is viewed like a promotion,
Even if their salary remains the same and they are losing purchasing
 power
Because Kinshasa is a more expensive city.
Here I was, moving from Kinshasa and coming to Kisangani.
But here is the thing:
Because everything is so centralized, the challenge remains
(Again, that question of responsibility)
What can I do about the so-called peripheries, about the margins?
Because we need artists in the most fragile spaces of our cities, of our
 communities.
Because if art can be of any use to society,
I don't believe in arts as just something out there
That doesn't play a particular role in any society.
For me, it is about creating, providing spaces
Where we can look at ourselves courageously
With our beauty, with our ugliness, with our fears, with our dreams.
It's about creating the spaces where we can imagine a possibility for
 ourselves.
So that even in a broken society like ours,
Where one is tempted to say, "the Congo does not exist,
There is only a river and the forest,"
Because the people are still there,
We can create these spaces, very fragile, very ephemeral, and ask,

What new dreams can we dream from here?

And when we moved to Kisangani in 2006
Our area of intervention started expanding beyond the arts.
Studios Kabako became this space where we invited other citizens to
 think with us.
Artists are essential in this process, but they are only one perspective
 out of many.
So that if we are in a community like Lubunga,
On the southern bank of the Congo River in Kisangani,
With almost 250,000 people
(I say *almost* because no one knows exactly how many people there are
 in this country,
The last census was conducted in 1984),
Even there, because there is no clean drinking water,
We can sit with other members of the community and say,
"OK, we are here. What can we do together about this water situation?"
So, we embarked on a journey to map out the water situation in Lubunga.
Water is not scarce here.
We are only seventy kilometers from the Equator; it rains all the time.
There is a lot of water.
Our problem is having access to water that will not make us sick.
With friends from the School of Architecture and Urbanism
At the University of Applied Arts in Vienna,
Led by Bärbel Müller, a professor there,
We mapped out the water situation in Lubunga.
We cannot provide clean water to 250,000 people,
But can we produce water for ourselves and for our neighbors?
That's how we started this project.
A tiny little project, a drop in the ocean of needs.
But every day, we can produce clean drinking water for a thousand
 people in that community.

And when we saw that the forest is really disappearing around the city,
And yet a lot of people still don't believe that the forest can ever
 disappear,
We started a project.

Virginie Dupray, who was the studio executive director for over fifteen
 years,
Came up with a project she called *Dessine-moi une forêt*,
"Draw me a forest."
It has been going on for nearly two years now.
And we are working with young people, fifteen of them, from this city.
It started with an artistic journey where we asked them to react to this
 title
Dessine-moi une forêt. Draw me a forest.
We received over a hundred and fifty responses in the form of songs,
 poems, and drawings.
We selected fifteen of them and we started a journey with these fifteen
 young boys and girls,
A scientific journey, with friends from the University of Kisangani
Where they spent time in different labs. They went to the forest,
They saw the effects of slash-and-burn agriculture, of timber logging.
Later, they worked with artists to retell their experiences of all of it.
Today, they start the whole journey of the tree
From seedlings in the forest,
They care for them in a nursery and transplant them back again.
It is a long journey, but we know that,
To quote Confucius,
At least it's attributed to him, I don't know if it's true,

If your project is for one year, grow rice.
If your project is for ten years, plant trees.
If your project is for one hundred years, educate children.

This is the journey we are embarking on today.
And especially after the Covid crisis, which we have not gotten rid of yet,
We realized that we need to rethink how we relate to our immediate
 environment.
We need to rethink how we produce food.

We need to rethink what we pass on to the next generations.

Again, it is about taking responsibility.

So today, I am on this new journey.
It is happening thirty kilometers south of here,
On the banks of a small river called Yoko.
And in Yoko, we acquired, with friends, 700 hectares of land.
That's over 1,600 acres of land.
The idea is to work with the community, to grow food differently,
To produce energy for cooking in a more sustainable way,
Because we still depend on charcoal as main cooking energy
And charcoal is partly responsible for the disappearance of the forest
 here.
But, because we still need charcoal, at least for the near term,
How can we produce charcoal more sustainably?
Because electricity is very scarce in the city.
As you can see, the city is dark tonight, and this is not news.
So, to grow food differently, to produce charcoal differently,
But above all, because a lot of these lands are degraded,
To dedicate at least 70 percent of the land to reforestation.
But to educate children, to educate our children about all this:
How do you produce your food? What about energy? What about the
 forest?
Because our project is for another hundred years, and we need to
 educate our children.

In the middle of all of this, one may wonder, what about the arts?
We tell these stories,

We also learn how to tell these stories,

Over and over and over and over.

We will probably need to learn new rites, new rituals.

We will need to invent new forms of storytelling,

Because it is like *The Magic Flute*,
When the world has crumbled the way it has now,
We must be like magicians, to bring it back to life.

And it's a journey through my ruins,

Through the ruins that we have saved from my ancestors.

A journey where I take responsibility, and say,
What can I do about it?
What can I do about this?
How can we imagine the possibility of a circle,
Even when we cannot meet physically and all we are left with is Zoom?
I'll stop here, so that even virtually, we can attempt another circle.

> *By looking at trees, I have become a tree. And this
> tree's long feet have dug great hollows of poison
> in the earth. Have dug cities of bones. By thinking
> of the Congo, I have become a Congo noisy with
> forests and rivers.*
> —Aimé Cesaire

Q&A

Could you share with us what this past year has been like for you, because it has been such a rupture for all of us around the world in all our lives. For you, this presumably has meant a complete change in rhythm, space, and relationship with different kinds of communities. In relation to the work you have been talking about in Kisangani and your artistic practice elsewhere, how did you spend the second half of 2020?

A

When all this madness started, I was in Europe, and so through the first lockdown until the end of June, I was in Lisbon, Portugal, with my family. After that, in July and August it was possible to come back to the Congo, and there was hope that this crisis was behind us and we could start afresh. But already when it started, my first reaction was that maybe life has forced me to stop. Maybe I have been running too much and now I must stop and take care of this body.

So, the first two weeks were a moment where I said, "Wow, I can breathe." After a time, you start realizing the depth of uncertainties. I must say that for someone whose work is based in the Congo, uncertainty is actually the name of the game. That is why it is so important to be able to improvise here. Improvisation is so important in my work, not only as a tool for generating material, but improvisation as a way of being. Because in a space where you just do not know what tomorrow will be made of, you need to be able to improvise your own life to just be able to survive.

From August to September, I was in the Congo, and because I had not performed since March, I decided that I could not go back on stage without performing a special ritual for myself. I made a trip to the village of Banataba, which is my maternal ancestors' village where my grandfather was born. A few years ago, in 2017, when I was invited to propose something within the context of the Crossing the Line festival in New York, I worked on a piece called *Banataba*. So, I went back to the village of Banataba and I performed the same piece there. It was like, "I came here some years back, and many of you were asking, what is it that I do? I came so that you can see me in what I have become. I need your blessing before going again." So, in one year I have only performed once, and it was in my maternal grandfather's village. This was special because during that trip I could reconnect with many parts of the family history that I did not know about.

I went to Europe, and immediately after I arrived it was lockdown again. I wanted as quickly as possible to come back here. There is something very grounding in being here, in thinking about what could be next from here and not from an apartment somewhere in Europe.

More than ever, I think about resilience. This has meant working with young people. Tonight, I am here with Chimène, who is making sure that you can see me, she is dealing with lights and sounds—she is doing everything. She is part of a team we have been training for some time now to make sure that this dream that we have here can continue. This situation has led me to work more toward setting up something in the Congo that will eventually continue to grow with this team and not need me.

Many of my students come from communities around the world where there is very little arts infrastructure. Could you please share ideas about how they might begin their journeys of creative outreach into their communities?

Q

A

One thing that comes to mind for me is the necessity to shift my idea of theater from a building, an architectural structure, to relationships. It is about relationships, and relationships must be negotiated, they are not a given, they take time to create. So, when we talk of responsibility toward a circle that is broken, and we are ready to play our part in mending that circle, we need to remember that even if we have found a circle, it is not given once and for all.

I was speaking with someone from Athens the other day and she was talking about the muses of ancient Greece. She said they never inspire you permanently. They visit for a while and then they go. You must work hard so that they can visit you again. It is like democracy. It cannot be a given, we have it and then it is done. We must constantly work for it. So it is about relationships, humility, patience, and perseverance. I can only speak from my own journey and say that it has been about long companionships. It has been a very long journey, which has not yet ended. It also means that at times it is not about producing artistic objects but about providing, just through our presence, a space where we can come together and reimagine things together.

You talked about ruins and the ruins of your country. There is a menu of options for ways of responding to ruins. The first is to figure out who did what and how it all happened and try to hold the perpetrators accountable. The second is to dig, rummage around, explore them to see what is left there and what stories they might tell. The third is to collect and preserve and reuse them, to rebuild what was there or something new. The fourth is to make a monument out of them. The fifth is to bulldoze them and start over fresh. Do these apply to the ruins you inherited? Are any of them appealing to you, or do you see other options?

Q

A

I have embraced many of these options. For a long time, I was obsessed with history. At first, I chose to deliberately look at the history of the country from independence to today. Not because colonial history has nothing to do with our ruins, but I needed to start with our own responsibility. What have we done as a people? Of course, we are not equally responsible for these ruins. I am not as responsible as Mobutu, but somehow, maybe because I had been complacent and I never found within me or around me the strength to revolt, I allowed it to happen. So as a people, we somehow share responsibility for these ruins.

It's only later that I started looking at King Leopold's and the colonial regime's responsibility in our ruins. That is when I started considering my dance as an attempt to remember *my* name. Names can be extremely deep and large because every name opens a web of relationships. If I start digging into these names, I see a web of relationships to people, to place, to history. Many would be shocked if I said, for instance, that I am called Linyekula because of colonial history. How come? Linyekula is not a Belgian or European name. But the thing is, until the 1930s, there was no family-name tradition in my country. Every person was named according to circumstances

surrounding their birth, and everyone had their own special name. These names could be connected to families, to clans, but everyone had their own name. Then, in the thirties, Belgians introduced the family-name tradition. So my grandfather, who was called Linyekula, started the Linyekula family. It is directly a fruit of colonialism. The moment you start digging into history, into a name, you see a whole world opening before you.

I started looking at my pile of ruins as a place where eventually I could get bits and pieces of material to build a temporary shelter for myself. Every work became like a shelter that I was building, where I could find a ritual from my grandmothers and from my Latin lessons with Reverend Father Pierre, a Belgian priest who came to the Congo in 1955. I could find a poem by Aimé Césaire or a pop song by Papa Wemba. It was all about scavenging through and saying, what is it that I can build as a temporary thing?

I think that of those five propositions, one that I have never embraced is bulldoze everything and let us start afresh. I come from a land where everyone is busy destroying something. So, to actually be a revolutionary here, to be subversive in this context, you need to start finding ways of building with whatever is there. Years ago I wanted to make a punk piece, and we needed to have a slogan. You cannot have a revolutionary movement without a slogan. The punks from the late seventies in England, they said, "No Future!" Maybe it was subversive for them, but for me, if I say, "No future!" I'm just reproducing the system. So our slogan became "More more more … future."

What drove you to return and how has your time abroad shaped your identity, practice, and process? Do you think an artist can work with the issues of a community that they are not part of?

Q

A

Coming back to the Congo, I realized that I had become a foreigner. It was clear that I needed to renegotiate a space for myself here. I have been doing so for twenty years since coming back. Identity is not a fixed position, it is dynamic. We are always becoming. I am sure that being on the road, based in Nairobi for six years, traveling to Europe, and on to the Indian Ocean reshaped who I was.

When I started making work in Nairobi, I spent a lot of time trying to challenge the proscenium theater—putting the audience on two sides, around, etc. But when I came back home, it became about the proscenium theater. It was as if I was coming home, standing in front of my grandmother and saying, "Look at me, I have traveled the world and I have come back to the wounds and the ruins of our land." Besides blood and memory, is there something we can build a future on together? Of course, it is already a lot to have blood and memory, but could there be more?

My journey has been about that. It is about not taking anything for granted, because nothing is given. You must negotiate everything over and over again. Opening myself to these stories from other places, other lands, helps me understand my own stories even more. It is about listening and being present to the moment. I trust in the magic of the encounter. It does not mean that it is always smooth. We could fight very violently but if we are honestly there, something happens. Even after we fight, as we are bleeding, we are walking away changed, transformed, and hopefully expanded.

THE WHITE PUBE

[IDEAS FOR A NEW ART WORLD]

Friday, March 26, 2021
Zarina Muhammad, London, UK

Moderator
Emilio Rojas, multidisciplinary artist,
activist, and art professor

Photo by Ollie Adegboye

INTRODUCTION

Emilio Rojas

I am honored to introduce The White Pube, the collaborative identity of writers and activists Gabrielle de la Puente and Zarina Muhammad, who began their publishing project six years ago while finishing their final year of art school. I often encourage my senior students by telling them that what they're doing now can have an impact outside the academic bubble of the school. I find The White Pube to be an inspiring and perfect example. Zarina Muhammad and Gabrielle de la Puente have been amplifying and voicing what many of us have felt about the art world and its criticism: a boring elitist sector dominated by white voices. If I am honest with you, I prefer to experience exhibitions, move through them, and feel them rather than read about them. Do I feel inspired and moved after leaving an exhibition? Does it light a fire or call me to action? Is it relevant to the urgency and movement of the moment we are living in?

I mostly do my reading of critiques when my friends get a review and mostly because they are *boringggg* (with four g's as Gabrielle and Zarina write on The White Pube website). Their articles are personal, uncensored, and critical, but always centered on their experience and the way their bodies move through the spaces. They talk to a new generation, without fear of being intimate and sharp, while experimenting with new ways of writing that advocate better funding, more diverse spaces, transparency, and equity. Every Sunday they publish text, audio, and video. Recently, the two have expanded beyond the art world and

into food and video games, tapping into our anxieties of making food and spending time through this pandemic. In the latest food post, Zarina writes, "I was raised by a single mother, so I didn't grow up with men in the house. If there are ever men in the house, it creates an unusual atmosphere. The polite vibrating air of having a guest." The White Pube does not stop just at writing; their platform expands into networks of support and care to other writers and artists. They have a successful funding-application library, and they offer a $500 grant to a different working-class writer based in the UK once every month. As an artist who struggles through applications and English as a second language, I find this research invaluable. In a moment where most of us are unable to visit art spaces and exhibitions, the voice of the collective "we" of The White Pube is loud, critical, and unapologetic, and just what we need in these unprecedented times of isolation to feel connected and alive.

[IDEAS FOR A NEW ART WORLD]

The White Pube

My name is Zarina Muhammad, I am 26, and I was born and raised in London, where I still live. I am an art critic, and I run a website called The White Pube with my best friend and collaborator, Gabrielle de la Puente. Gabrielle is based in Liverpool, where she also grew up. We met in London, at Central Saint Martins, where we did a BA in fine art. Back in 2015, during our final year of art school, we talked about exhibition reviews and how they were boring and said nothing, just bad chat by mostly middle-class white men. We decided that we would start writing about art and how it made us feel—happy, bored, angry, in love—and began publishing texts that were critical of the absence of representation and accessibility in the art world. Someone would later tell us this was an embodied criticism, expressing body-first encounters in the gallery. From there, we started to write about the wider creative industry, rallying for better conditions, fairer spaces, and transparency. More recently, we began to write about video games and food as well.

Since 2015, we have published our writing on our reader-supported website, thewhitepube.com, and on Instagram and Twitter. Though we are not set up as an official organization and our office is a WhatsApp chat room, we have developed specific working standards. We publish our financial accounts, run a working-class writers grant, and have a growing library of successful funding applications. We publish a new text every Sunday, and we take the month of December off as annual leave.

The context we exist within can be a bit specific; for an international audience, the UK's art scene could need a bit of translating, so I will do a whistle-stop tour of all the highlights. Most arts institutions in the UK are publicly funded. We have a pretty stable conceptualization of the way art and culture function as a public good. Art and culture are of benefit for the public, they are to be enjoyed by the public, and so, collectively speaking, they are funded by the public. Or at least they should be. Historically, for the past couple of decades, at a state level the UK has been ravaged by a top-down dismantling of public services, consistent with the neoliberal political project.

Slowly and deliberately, funding for everything from our health care to the railways to our museums and universities to public services is being slashed to the bone and turned toward the open arms of corporate finance and private funding.

London, too, has changed. There is now a housing crisis, and it is common for people to be priced out of the neighborhoods they were born

and raised in. Gentrification is a rolling backdrop, sweeping farther and farther out in a radius through the city. In 2010, a general election ushered in a right-wing coalition government that raised the cap on tuition fees for higher education. Students at UK universities must pay £9,000 a year for their tuition fees, and many people are priced out of education past the age of eighteen. Wages are falling; zero-hour contracts and precarious and often exploitative working arrangements are common, especially among younger people newly entering the workforce. The unions have not had much power since Margaret Thatcher, and all in all it is quite difficult to be a twenty- or thirty-something in the UK at the moment.

The art world in the UK doesn't do much to help its workforce find a footing in a country gone AWOL, making it difficult to find stability. In the UK, the arts are less ethnically diverse than the banking sector. Institutions hold the power, and they tend to be made up of white middle-class people who give out jobs and opportunities to other white middle-class people. It is almost impossible to make a living in the arts if you are not white, middle class, and nondisabled, or if you are precarious or marginalized in any way. Efforts to address this imbalance are unsuccessful, and institutions are caught in a perpetual cycle of trying to engage a structurally marginalized demographic without ever engaging in any internal structural change.

At the beginning of April 2020, at the start of this pandemic and all of its catastrophe and chaos, we at The White Pube published an essay titled "ideas for a new art world." I had just read Lola Olufemi's book *Feminism Interrupted: Disrupting Power* (Pluto Press, 2020), which is a careful and detailed description of a feminist politic that is both expansive and fundamentally hopeful. The book begins with "Feminism is a political project about what could be" and continues to describe a logic that is both optimistic and grounded in the real lived world. It is a verb, a doing word, but even in theory it never lets go of a speculative potential for a better condition of being, one that is less about a rigid dogma and more like an approach to viewing the social, political, and material structures we exist within.

The book left me with an energy and optimism, a tender love, and aspirational hope for the potential of a future world. I took its energy and

wrote "ideas for a new art world."[1] The ideas in that text were mostly about rethinking the structure of institutions, payment, and funding. Things like paying everyone in an organization the same generous living wage and a more horizontal approach to decision-making, such as collective cooperatives that work together, rather than having a single director or select curators. What if regional councils offered empty high-street shop units to small organizations to use as free spaces? Some of these ideas were new to us, but some of them were things we had written about before, like community consultation and Gabrielle's 2017 text "Local Advisory Boards: A Sensible Idea."[2]

"ideas for a new art world" was written in the hope that gentle suggestions for attainable improvements would linger just long enough to make space for something good to grow. The list of ideas was getting long, and there were too many holes to seal. At the end of 2019, we had an opportunity to think about this list of ideas in the form of billboards. The creative street-advertising agency Jack Arts had us participate in the company's side project, Your Space or Mine, to convert six billboards with our list of aphorisms, offering simple and feasible solutions. Our good friend and graphic designer Amad Ilyas gave our website a make-over and made us a color palette and graphics called pubemojis.

We wanted the statements to be fun, optimistic, hopeful, and aspirational and joked about them being these millennial Jenny Holzer aphorisms but written in Twitter speak and with a very specific agenda. The billboards first appeared in London and Liverpool, and after the first week they were rolled out across the UK in Bristol, Cardiff, Glasgow, and Manchester.

None of the ideas we present are particularly

1 Zarina Muhammad, "ideas for new art world," The White Pube, 4 March 2020, bit.ly/ideas-for-new-art-world.
2 Gabrielle de la Puente. "Local Advisory Boards: A Sensible Idea," The White Pube, 26 November 2017, bit.ly/local-advisory-boards.

radical, they are just common sense, but the art world operates in this wild space that makes them feel outlandish.

Some of them have been controversial in ways we completely did not expect or understand. Maybe it is something about how blunt and short the statements are, how they completely reject nuance, justification, or explanation. They speak in absolutes about these complicated problems.

001: if i were the Tate, i would simply remove my racist paintings

The Tate Britain is arguably one of the UK's biggest and most culturally significant museums. Located in Millbank, just on the river, it is an impressive Georgian building, dedicated to housing a historic collection of culturally important British art. In the basement, there is a restaurant called The Rex Whistler. It is pretty fancy: white tablecloths, waiters in crisp white shirts, columns, and nice wine glasses. The walls of the restaurant are covered in an extensive floor-to-ceiling mural titled *The Expedition in Pursuit of Rare Meats* (1927), painted by the British artist Rex Whistler, whom the restaurant is named after. Commissioned by the director at the time, Charles Aitken, the painting depicts the fictional land of Epicurania. In the painting, the expedition group of the Duke of Epicurania and his courtiers go off hunting in search of rare and exotic game. I have never been inside The Rex Whistler restaurant, but interpretations of the mural describe it as "bizarre and enchanting." It depicts the hunting group that comes upon creatures such as unicorns, truffle dogs,

and two giant gluttons guarding the entrance to a cave. Another scene renders a black child's enslavement and his mother's distress. It shows the child "running behind a horse and cart, which he is attached to by a chain around his neck."

In 2013, the mural was restored as part of Tate Britain's £45 million refurbishment. That same year, the Tate's ethics committee noted the offensive nature of the mural, for the first time, in the public minutes of the meeting of the Tate Board of Trustees. In the following seven years, the Tate adapted the mural's interpretive text, making it available upon the diner's request and for purchase in the nearby gift shop. This interpretation, the only thing the Tate acted upon to address the racist imagery in the mural, candidly began with "the most amusing room in Europe," and it was not until July 2020, following the murder of George Floyd at the hands of police and the subsequent waves of Black Lives Matter protests in the United States and around the world, that the issue of The Rex Whistler mural was raised. This time it was by members of the public. Cultural institutions in the UK faced their own reckoning with their structural racism and the ways they perpetuate and enact anti-Blackness specifically. That summer the Tate released a statement reaffirming its commitment to combating racism and claiming to stand in solidarity with protestors: "[M]aking a statement is not enough. To address structural racism and the inequalities underpinning society, we have a responsibility to act ... We're committed to changing this [this being racism] through our work, and to challenging ourselves to dismantle the structures within our own organization which perpetuate that inequality."

Soon after, a petition for the mural's removal circulated, and the Tate's reply to the public stated: "Tate has been open and transparent about the deeply problematic racist imagery in The Rex Whistler mural ... [T]he mural was one of the artist's most significant works and is part of a Grade I–listed[3] historic interior. But it is important to acknowledge the presence of offensive and unacceptable content and its relationship to racist and imperialist attitudes in the 1920s and today. ... The interpretation text on the wall alongside the mural and on the website addresses

3 A ranking of the highest significance for works of particular architectural and/or historic interest deserving of special protection, maintained by Historic England.

this directly as part of our ongoing work to confront such histories, a process that goes hand in hand with championing a more inclusive story of British art and identity today."

The Tate then updated the interpretation by removing the reference to the restaurant as "the most amusing room in Europe." Since then, the museum's ethics committee, led by Canadian postal executive Moya Greene, has again investigated the mural's place within the institution. The committee reported that its members were "unequivocal in their view that the imagery of the work is offensive"; however, the work "should not be altered or removed." In December 2020, the racist mural and The Rex Whistler restaurant at Tate Britain were closed until further notice. Yet closure is not the same as removal or a formal apology and contrition. Closure is not the same as reparative justice, and closure is not meaningful engagement with overt racism made explicit in Rex Whistler's mural, depicting black subjects as subhuman prey. Closure just means the doors are shut, but the problem remains.

There are options for the mural to remain as a piece of British art history if we use our imagination and think beyond rapid reflexes. Removal is not a finite possibility or even an end point. It offers the Tate a genuine opportunity to do something meaningful toward their goal of "challenging themselves to dismantle the structures within their own organization which perpetuate inequality." Current conservation technology now means that historic paintings, a lot older than the ninety-three-year-old Rex Whistler mural, can be reversibly altered and covered up, successfully removed and resited, or archived in exact high definition for the sake of posterity.

In June 2020, protesters in Bristol toppled a statue of slave trader Edward Colston. The statue was then rolled down Anchor Road and pushed into Bristol Harbour. Four days later, Bristol City Council retrieved the statue from the harbor, cleaned it, and announced plans to exhibit it in a museum without removing the graffiti and ropes placed on it by the protesters.

Removal offers the Tate the chance to move beyond gesture and toward an enacted structural change for the better. The White Pube supports them wholeheartedly in this difficult process of overhaul and encourages them to consider the potential opportunity within removal.

CURATORS SHOULD ASK THE PUBLIC WHAT THEY WANT TO SEE AND WHAT THEY THINK GALLERIES AND MUSEUMS SHOULD BE USED FOR.

002: Universal Basic Income and affordable housing, so that everyone, including artists, can make a living

Universal basic income provides adequate pay regardless of a person's profession or success, and without a means test or work requirement. The financial package would be sufficient to meet a person's or family's basic needs and ease the pressure of the increased cost of living. We understand that there are sound leftist critiques of UBI as well as a significant chance that governments could use UBI as a vehicle for dissolving the remains of the welfare state, especially considering the UK's current Tory government or the previous decade of Tory administration, which stuck to a hard-line policy of austerity, and the consistent political trend of decimating public services and cutting public spending to the bone. Within that are important nuances; the amount of money each of us requires to meet basic needs can differ hugely based on location, living costs, mobility, and support needs. Judging from the UK's housing crisis, across the country and in London specifically, this policy could effectively amount to state subsidization of landlordism.

This idea is a soft suggestion. It exists in a more receptive world where other suggestions have been taken and good faith is assumed. It is an idea that speaks specifically to the issue of artists unable to make work because the conditions necessary for survival are labor-intensive, depleting one's time and energy for creativity. It is an open topic of conversation in the circles we move through, but artists often have day jobs because the precarity of the culture sector is too unstable to rely on for survival. Few artists can make ends meet by selling work or through a studio practice alone. Some artists teach in universities, others work in galleries, as technicians or invigilators, and in gift shops. Some have jobs entirely outside the art world, in retail, in offices, and doing odd jobs. The pandemic has made clear that the sector we work in is unreliable and that work itself is uncertain.

Additional funds to cover one's basic needs could alleviate the pressure of fitting a studio practice around hustling a part-time or full-time job. If you had access to stable and affordable housing, you would not have to worry about how you were going to pay rent between all these precarious low-paying jobs. Everyone deserves to be able to live comfortably and afford basic necessities like housing and food.

003: Curators should ask the public what they want to see and what they think galleries and museums should be used for

"Curators should ask the public what they want to see? You would probably get Bob Ross, Rolf Harris, and Jack Vettriano. After all, 'ask the public' gave us Brexit." I feel like when people say this, they are not exposing a bigoted public but instead are revealing their own internal bigotry and bitterness.

I picture an art world where curators do not impress a singular taste or long and limited vision that never changes upon the exhibition space (something is almost always harder to bear because it is white, straight, cis, nondisabled, and unbearably middle class). I picture an art world where curators think beyond themselves; step back, share, listen, facilitate; and do not confuse taste and quality, knowing that something can still be good and loved by others even if they do not like it so much themselves.

I wish it was normal for curators to ask people what they want to see in the gallery, as a way of being of service to the audience *and* surrounding art scene: What would be useful or exciting? What would make you get out of bed, jump on the bus, and come all this way to see our shows? A singular curatorial vision cannot possibly fulfill these questions for everybody. Ideally, curators would work as part of a team and regularly invite portfolios, exhibition proposals and conversations, give feedback, and sit down with anybody who wants to have a chat. Curators should be transparent about what they have at their disposal and what they might be able to offer in the way of funding, opportunities, curatorial and critical support, meeting with other arts professionals, materials, and so on. It is a simple, generous, and positive approach where curators can empower the individuals who make up their local art community.

The billboard makes a second point: an art institution's galleries should not serve only as exhibition spaces but also as community-organized space for social justice organizers, offering support to the people resisting right-wing governments, police brutality, racism, transphobia, austerity, and other methods of state violence. "Curators should ask the public what they want to see and what they think galleries and

museums should be used for" is an achievable philosophy for a space to have, and one that I have used at OUTPUT gallery, the space I run in Liverpool. I think its approach is simple and functions on the same level as the people who use it. I don't think it is too wishful or radical to say that all publicly funded projects should do the same.

004: people across the creative industries need to declare if they have rich parents who helped them get where they are today

There is an organization in London called the Barbican Centre, located in an estate famous for its brutalist architecture. When I was an art student, I went to see a show by Eddie Peake titled The Forever Loop at the Centre's exhibition space, The Curve Gallery. It was funny and cool and felt like an artist was finally causing a ruckus at an otherwise big middle-class place. There were girls on roller skates moving through the crescent-shaped space and huge words masked out on the wall, which had then been painted over in neon pink. I remember scaffolding, sculpture, and I think there was music, all at once. I saw the work at a time when I was weary of being silent in independent galleries, politely looking at the art, and hyperaware of my body in the space. I thought that it was good to know artists were allowed to have fun with their exhibitions. Then, a few months later, I learned that Eddie Peake's mum was Phyllida Barlow, a hugely famous British artist, with a Wikipedia page of her own, and that they lived in a nice big house. Suddenly, all the edge and coolness I had enjoyed in her son's show evaporated. No, I don't know if that is fair to say, but it is what I felt in my gut.

I read a Tweet the other day by @EJhavingfun that said, "I have a disease called: when I find out someone grew up wealthy, I don't think they're funny anymore." I have that same disease for contemporary British art. The work Eddie Peake made didn't change. I just felt a new disconnect between the work and myself, the artist and me. A disconnect of wealth, opportunity, privilege, influence, health, future, and security. The artists I know IRL squeeze their artmaking in between their day jobs, their own life admin, their kids, and sleep. Their lives, and all

the labor required for their continued survival, is mostly not conducive to the creativity or the logistics one needs to create a massive body of work that would fill a space like the Barbican's Curve Gallery. Yet, when other artists walk into these galleries, crushed under the weight of their own working-class lives, they wonder how it is possible that someone else has managed it.

It is not fair to them, to not know when the work they are seeing is by a rich kid whose life comprises back-to-back residencies and endless studio time. It is not fair to other artists, and it is not fair to the audience either. I feel like it pulls apart the world, where art made by the elite is automatically certified, advanced; and anything made by people who do not have access to studios, time, space, exhibitions, biennials, and art fairs does not qualify in the same way. When rich-kid artists make art with *our* aesthetics, they camouflage themselves to look like us, speak like us, and feel like us, so that we cannot see their class anymore. It is especially painful and suspicious when writers, TV producers, and journalists exploit the richness of lower-class culture as their subject matter. Kim Kardashian once posted an incredibly professional-looking Bob Ross–style oil painting of a rolling mountain landscape on her Instagram story. The gag was her seven-year-old daughter, North West, had painted it, and no one on the Internet believed it. Kim clapped back at the accusations, saying that her daughter and best friend had been taking serious oil painting classes that encouraged and nurtured their talents and creativity. Naturally, the child of two billionaires can take classes and make that painting. In fact, that is a perfect encapsulation of how money opens doors and makes the hallways of life smoother and steadier. Rich kids surely still must work, but they have this facilitated ease of access to incredible resources, knowledge, and skill through their parents' money, making their work more likely to pay off.

It can feel like a big mystery with one left asking why so many artists are middle class. It is not really about the overt removal of working-class people from the arts—though I can assure you, that happens too—it is about endurance-testing people, and how equipped we all are through various means to withstand that test. Our endurance is often predicated on the privileges wealthy parents can hand down and the access and influence they are able to buy early on. North West has a real talent

for painting, but it is a talent that many other kids just cannot afford to nurture or even discover in the first place.

005: the art world should not replicate the capitalist structures of other industries and instead should set a better example with a horizontal approach to decision-making and pay

In the UK, we have a specific set of problems that come from having a government and private sector both widely and deeply invested in the neoliberal political project. In the original "ideas for a new art world" text, I outline sincerely good reasons why rethinking the way art institutions are structured would be a good idea.

The culture sector, like almost every other sector, has some massive gaping holes around the distribution of resources, most of all money.

Directorial salaries in the UK can go up to six figures. For example, the director of the Tate, Maria Balshaw, earns £165,000 a year, while the majority of her staff are moved onto precarious zero-hour contracts and their jobs outsourced to private companies that actively shut down unionization efforts.

In the UK, galleries and arts institutions are meant to be publicly funded by taxpayer money. If they are not meant to be following

profit-making capitalist models, then arguably there isn't a good reason for them to have the same structure as a profit-making corporation. The sector is not required to offer six-figure salaries at a directorial level to attract talent. The art world already exists within a cloister that requires a significant level of investment in time and effort and a specialized and rigorous conceptual arts education—while the role a director plays within an organization is so far removed from the actual day-to-day running of the gallery that, at six figures, they are our sector equivalent of a landlord earning money from purely overseeing something by name. Directors play a symbolic function that only makes sense if there is belief in the singular vision of an individual's corporate-style leadership.

An attempt at horizontality throughout an organization already exists in the UK art scene. There are organizations that pay everyone the same living wage, from the bottom to the top, from the directors to the people that clean the floors at the end of the day. My day job is for a social enterprise where I am paid the same day rate as everyone else, including the cofounders. It is a model that still works, even if the end goal is to make money from commerce rather than public funding. By making the economic model more horizontal, institutions would open themselves up to a more collaborative, cooperative mindset—at an organizational level, and individually among workers. What is possible when everyone has the same amount of skin in the game?

I think it would open institutions up to new radical thinking from their workforce. There is a wealth of talent within the art world that remains unappreciated because of the current structures. We do not need to go outside ourselves to seek new answers to old problem. The solution is right in front of us—it just needs to be facilitated through a radical overhaul of the current structure.

006: dear museums, give back all stolen objects

The repatriation of human remains seems to be cut and dried, especially as a legal issue. There are specific avenues for countries to take so that the remains that have been stolen can be returned. But this is not the case for the repatriation of looted or stolen objects. For some reason,

the British Museum is still in possession of stolen objects whose return has been requested time and time again by their country of origin. The Benin Bronzes and the Elgin Marbles are high-profile contestations that both museum and government are willing to take public and international heat for. The stolen objects in the British Museum are the loot of its empire. The UK's reality as a deeply and insidiously racist country is no secret either, from the racialized victory of Brexit and the decision to leave the EU to Megan Markle's experience of explicit anti-Black racism from the heart of the British royal establishment and British press, the over-policing of Black and Muslim communities, and the asylum reforms proposed by the home secretary to close off almost all paths to citizenship or the right to remain for refugees and asylum seekers.

Racism is deeply embedded within the machinery of the UK's operational social structure. Its colonial history, since the 16th century, is the point where that racist structure was built, and to this day the country is neither post-racial nor multicultural. It remains the place where racism was invented. There is no way to move on from this point without coming to terms with the violence of this history. Keeping stolen and looted objects from the British Empire's colonial rampage across most of the known world is untenable, morally and politically. The performative gesture that has made up the bulk of UK institutions' attempts to decolonize themselves feeds their idle conversations and only adds further insult.

To dismantle the web of racist structures throughout the country requires the culture sector's decision to return

the stolen objects. Only then would the culture sector show sincere action toward restorative and reparative justice.

Q&A

I wonder if you can tell us more about the journey from not liking art criticism to having this idea and collaborating to form the White Pube, to then having a much, much more critical and activist approach. I'm interested in your process, from dissatisfied art students to this manifesto for "a new art world."

Q

A

Yeah, sure. I think it makes sense to us that we would be dissatisfied art students who then actually did the thing that we were complaining about—just plugged the gap. It makes sense to us because we went to Central Saint Martins and we noticed that each individual art school has its own thing that it does really well specifically. At Central Saint Martins, the teachers were really good at teaching us how to think about the political implications of the art that we were making. We weren't necessarily making these really polished objects, but we were really, really good at having a conversation about the way that this art sat in a room and the way that it took up space and what that implies. That was just a part of our rumbling backdrop. So it made sense when we were having a conversation about the shortcomings of the art writing we were running up against—between those two points of journalism, which doesn't really say anything at all, and theory, which is impenetrable. And it was like a reflex. We were just like, we should do it ourselves. It just popped out of that, the way that we were used to talking about art, which was a bit more considerate of the political implications. We were super-quick to jump in and say that we should do it ourselves.

When Gab [Gabrielle de la Puente] asked what we should call it, apparently I yelled "The White Pube," and I don't know where it came from, like it was fate or celestial intervention. And I think with a name that good we felt like we had to do it now, like we had to manifest it into existence, because the name's too good, we can't fall short, we've got to commit at that point. I think that kind of was how two disgruntled art students became art critics.

In terms of the critical and political edge of our criticism, I think it's tied to our identities. There is no way I can go out into the world and write a review of a white artist's work without considering what it means that they are a white artist and I'm a brown critic. I can't vacate myself or my identity in the way that Clement Greenberg could, for example. Greenburg could just write in this way that was academic and objective and use that disembodied authorial voice. I can't really do that, or I don't want to. I don't want to write in a way that doesn't acknowledge my lived reality as a brown Muslim woman in London. I want to write from that position. It's interesting and exciting for me, and it offers me so much more richness to explore.

I'm curious about working with advertising agencies. I think it's great to get these ideas out there, obviously, but I worry that they're only giving these spaces to artists when there's nothing to advertise. How do we reclaim the spaces away from advertising?

First, I think that's a really good point: advertising agencies have corporate clients. They have paying clients, and maybe they're really cool clients like galleries and publishing houses. They want to do something a little bit

edgy and cool, but still fundamentally they're corporate clients. We're not being paid and we're not paying to do those billboards; we're just kind of leveraging.

There are still questions about the social or political implication of exhibiting on billboards; it still needs to be questioned and I don't want to shy away from it, because I think it's a way of talking about artwork and public artwork that is really important. But we're just chancers—if it sounds good, and it lands in our inbox and it sounds like something that we can use in a way that would be interesting or useful, I think we're going to try to say yes to it anyway, regardless of whether we are being utilized or tokenized in some way by that agency. I think it raises an interesting question, but I love being a chancer, love being jammy.

Can you see The White Pube becoming bigger than just you and Gabrielle in the future, because obviously it's very much about your own relationship and your friendship?

Q

A

For us, we've really rejected that capitalist model of expansion, that idea that we have to grow and grow and get bigger and bigger to be more successful, like constantly upstaging yourself. I think we've really invested a lot of time and effort in attempting to not do that because I don't think that that model of growth is one that suits us.

The White Pube is a model that emerged from the overlaps in our individual studio practices and emerged out of those shared complicities, and it's based fundamentally on the trust that we have and the way that we are complicit in each other's agenda. I trust Gab with my life, and if we invited someone else

in, I don't know if I could say that for them; I can't vouch for other people in the way that I can vouch for her, so I don't think we would grow or expand or add another person into the mix.

In terms of The White Pube getting bigger than ourselves, like as people individually, in a way it already is: it's a collaborative identity that exists that we can project as an image, and sometimes I really like referring to the things I do with the plural, like the royal We.

It's bigger than me, myself, as a person. This collaborative identity of The White Pube can say certain things that I perhaps would be a little bit tentative to say as a person for fear of being labeled aggressive or angry. I can't necessarily say all these quite risky things to institutions, but I can say it as The White Pube because The White Pube has a certain power.

The billboard slogans are fantastic but slightly confusing. They describe the problems that need to be addressed as complicated and then the solutions as simple, if we really want to solve them. Are you sticking to that story?

Q

A

I think maybe that's a lack of clarity then, because I think the way that the creative industries conceptualize these problems is quite complicated, it's quite tangled.

These institutions pretend that racism is this really big issue that they can't solve, and they need multiple task forces to try to comprehend and get to the bottom of these problems. But if you ask Black and brown artists what institutions can do to combat the structural racism they experience, there are pretty clear answers. It's just about who you're asking and what questions you're asking.

The solutions we're presenting are these very simple, easy fixes. Like universal basic income. It's a three-word answer; that's a really simple answer. The money exists, but there is this block on the political imagination that conceptualizes it as complicated.

So I guess I am sticking to that story. I don't think there's a dissonance between those two things—the idea that those could be complicated questions and that there could be easy solutions. I don't think there is a cognitive dissonance from our end, but rather that capitalism has this split logic, and that's where the cognitive dissonance is.

Q

I agree it's a no-brainer to ask museums to return the looted art pieces to the countries of origin, but what is our responsibility as artists toward these pieces when it's also a no-brainer to say that returning pieces to some of the countries of origins will be like throwing them away. I speak from Lebanon, where our government couldn't care less about our lives, let alone our art.

A

You ask a complicated question. That's the argument that a lot of the directors of museums in the UK use. That's the way that they make the justification for hanging on to these objects. Tristram Hunt, the director of the V&A, wrote a think piece a few years ago in the *Guardian* about why we shouldn't bother giving these objects to these countries. When Tristram Hunt says that, it reads as paternalistic; it's really, really condescending for him to be saying that, because it frames it like, "We can't give these objects back to these fucking savages." Basically, we can't give it back to these people, they don't know what to do with it, you know. Or maybe he'll say it a bit more genteel and he'll be polite

and he'll say, you know, these countries don't have the storage facility, they don't have the environment required to house these objects safely in a way that prioritizes conservation. In which case I'd tell him, yeah, cool, you pay for it, maybe the V&A should give the money, if you're so concerned about it. Because fundamentally the moral argument is pretty clear; and if that moral argument is clear that those objects belong in those places, then I think any kind of economic argument or concern around whether they will even be valued in those countries that they go back to feels secondary to me. Maybe it's something you disagree with, and that's absolutely fine. I'm not looking for complicity from an audience, but I think we've got to be careful about the way that especially white museum directors talk about and justify reasons for hanging on to these objects, because it slips into actual explicit racism, obviously, really quickly.

I'm a student from Bangladesh and my question is if curators started asking the public what they want to see, don't you think it can have a negative impact in terms of quality?

Q

A

Whether opening the doors to public consultation or public input, whether that would result in a lack of quality, I think maybe that is a super-liberal way of conceptualizing it and is a product of liberal democracy.

I think that that's not necessarily what public consultation has to amount to. There are ways of organizing, like anarchic communalist political models that involve the idea of consensus, or are much better at working their way toward consensus than perhaps liberal democracy is.

And the idea that compromise can be affected, the idea that compromise can turn a decision into "a horse designed by committee"—the idea that that is the only singular output of communal decision-making is really a Western one. I mean, you're from Bangladesh, and so is my dad's family. So perhaps that is less the position you're speaking from, and more about the way that we all collectively think about the way decision-making has to go.

There are communal models where decision-making is a bit easier and smoother. It's a bit more about being in open communication with each other, and not necessarily about which side wins.

I think I would have more faith in the public. The public aren't necessarily these awful people who must be repelled at all costs. That conceptualization of the public seems to come out of high modernist thinking and is pretty elitist in my mind. I think we're speaking from very different positions, and that's fine.

CASSILS

THE STRUGGLE FOR /THE STRUGGLE AGAINST

April 2, 2021
Cassils, Los Angeles, USA

Moderator
Sahar Assaf, Director, Golden Thread Productions,
San Francisco

Photo by Robin Black

INTRODUCTION

Sahar Assaf

Born in Toronto, raised in Montreal, and currently living in Los Angeles, Cassils is a transgender artist who makes their own body the material and protagonist of their performances. Their work investigates historical context to examine the present moment, contemplating the histories of LGBTQ+, the violence inflicted on the community, its representations, struggle, and survival. For Cassils, performance is a form of social sculpture, which draws from the idea that bodies are formed in relation to forces of power and social expectations. Their recent solo exhibitions include the Perth Institute for Contemporary Art (2019); Station Museum of Contemporary Art, Houston (2018); Pennsylvania Academy of the Fine Arts, Philadelphia (2016); and MU Hybrid Art House, Eindhoven (2015). Cassils is the recipient of the 2020 Fleck Fellowship & Residency at the Banff Centre for Arts and Creativity; the USA Artist Fellowship (2018); and the John Simon Guggenheim Fellowship (2017), among others. Cassils' work in live performance, sculpture, photography, installation, sound design, and film has been featured in the *New York Times*, *Boston Globe*, *Artforum*, *Wired*, the *Guardian*, and *Performance Research*. They were the subject of the monograph *Cassils* (MU Eindhoven, 2015).

Cassils has been often referred to as an artist who makes you look, who makes you think. *In Plain Sight* (2020) is one of their recent live shows that I find extremely inspiring and fascinating. When theaters, museums, and performing arts centers closed down due to the pandemic, and

while most artists either canceled their shows or moved them into the virtual world, Cassils and their collaborators went to the "queer blue sky," as they call it, to create a live performance that feels so intimate despite Covid social distancing and one that dismantles all dominant theater architectures. This is a performance that goes to the audiences, reaches out to them, wherever they are, at the moment they witness it. It is free and accessible to literally everyone under the sky and the nation. It does not give us much of a choice—we are forced to witness the performance. The only way we can hide from it is by not looking up, which in itself becomes a conscious and active action. The work compels us to become witnesses and likewise come to terms with whether we choose to watch it or not. It makes one know, and by knowing, it makes us recognize our ethical responsibilities. It is a quality one can find in all of Cassils' work.

This talk is titled "The Struggle For / The Struggle Against," and Cassils discusses artistic and performative tactics uniquely suited for our time. Reflecting on ten years of practice where they have carved strategies for trans representation, Cassils discusses tactics to educate, engage, and agitate while attempting to balance and center love, community, and relevant action.

THE STRUGGLE FOR / THE STRUGGLE AGAINST

Cassils

My name is Cassils, and it is an honor to speak with you today. I am beaming to you today from Los Angeles, the ancestral homeland of the Tongva people and the Chumash Nation. California was home to thousands of people, around 350,000 across the whole state, before Spanish settlers arrived. The Los Angeles Basin, in particular, was home to the Tongva people, and their movements set the stage for what would eventually become Los Angeles: their footpath through the Sepulveda Basin was the original 405 freeway. The L.A. State Historic Park was formerly the Tongva people's largest known village in the area. Their influence on the eventual metropolis of Los Angeles extends far beyond their choice of location, though; the forced labor and enslavement of Tongva people is what allowed Spanish settlers and missionaries to develop their reach in the first place. I start this way because it is important for us to understand the long-standing history that has brought us to reside on the land and to seek to understand our place within that history. Colonialism is an ongoing process, and we need to build our mindfulness.

On March 4, 2018, I received the tragic news that James Luna, one of the most important performance artists I have known, had a heart attack suddenly and passed on. I have been thinking a lot about Luna, the lessons he taught us, and the importance of his presence on this planet. "In performance art, you show by example," he said. "I'm not out there to preach. People can make up their own minds."

In the beginning, he said he created his artwork as a form of public therapy. Having a master's degree in counseling, he knew that the first step in recovery is speaking directly to the issues at hand. In *The Artifact Piece* (1985–1987), Luna uses his body to make a powerful commentary on the objectification of First Nation cultures in museum exhibitions, and on the tendency to freeze Native peoples in the past, presenting them as artifacts rather than as living members of contemporary cultures. He wore a loincloth and lay still on a display case surrounded by labels with other cases containing personal ceremonial objects. However, in an unsettling twist, the viewers find the subject of their voyeurism looking right back at them.

Luna knew that visibility is a trap. This is something I think a lot about in relation to my own subjectivity. The increasing representation of trans identity through art and popular culture, in recent years, has been nothing if not paradoxical.

Trans visibility is touted as a sign of a liberal society, but it has coincided with a political moment marked both by heightened violence against trans people, especially trans women of color, and also by the suppression of trans rights under civil law.

A new collection of essays published by MIT press called *Trap Door: Trans Cultural Production and the Politics of Visibility* (2017) grapples with these contradictions. It posits that trans people are frequently offered up as "doors," entrances to visibility and recognition that are actually "traps," accommodating trans bodies and communities only insofar as they cooperate with dominant norms. The volume speculates about a third term, perhaps uniquely suited for our time, the concept of a trapdoor, neither entrance nor exit, but a secret passageway leading *elsewhere*.

I had the pleasure of meeting James Luna at the Hammer Museum in Los Angeles. Luna told a story of chatting to his friend, a fellow artist on his reservation, regarding his frustrations about being pigeonholed as a Native artist in the art world. His friend looked at him with perplexity and said, "You think you're in a box, but for us you are on a pedestal. You actually have a voice." I have thought a lot about this in relationship to my own practice, being constantly and mostly referred to as a trans-gender artist. Of course, this is part of who I am, but it is certainly not a summation of my entire art practice. There was a certain profundity in

Luna's anecdote, which reinforced the importance of standing up and speaking out.

In each of my artworks, I train my body for different purposes, whether it is being pressed against ice, gaining twenty-three pounds of muscle, pummeling clay or being lit ablaze. My live durational works and the resulting performative objects melt, flash, and burn with visceral intensity. I think of the body as a sculptural object, bashing through binaries and the notion that in order to be officially transgender you have to have surgery or take hormones.

I perform trans not as something about a crossing from one sex to another, but rather as a continual becoming that embraces indeterminacy, spasm, and slipperiness.

Cuts: A Traditional Sculpture (2011–2013) was a six-month durational performance in dialogue with Eleanor Antin's 1972 performance *Carving: A Traditional Sculpture*, in which Antin crash-dieted for forty-five days and documented her body daily with photographs from four vantage points. In my iteration, instead of the feminine act of wasting, I use my mastery of bodybuilding and nutrition to gain twenty-three pounds of muscle over twenty-three weeks via a regiment of force-feeding the caloric intake of a 180-pound male athlete, grueling workouts, and six weeks of steroids. Like Antin, I took a photo every day from four anatomical positions to document my transition. My title, *Cuts: A Traditional Sculpture*, is a

twist on "getting cut." It queers the trans body by showcasing the cut of musculature as opposed to the cut of the surgeon's knife. When I reached the peak of my conditioning on the 160th day of this performance, I collaborated with photographer and makeup artist Robin Black to create *Advertisement: Homage to Benglis* (2011), in which I staged a homage to Linda Benglis's *Advertisement* (1974). Rather than buy advertisement space in *Artforum* as Benglis did to tap upon the glass ceiling of the art world, I capitalized on my connections in gay, fashion, and art publications to disseminate these self-empowered images of trans representation. The work wound its way through the internet, ending up on gay male versions of "hot or not," where I would steadily climb up until suddenly people scrutinizing my pecs realized they were breasts and my image would disappear.

In May of 2016, *Homage to Benglis* featured in an advertisement poster for an exhibition at the Münster Museum. The advertisement was soon censored by the Deutsche Bahn, the German railway company controlled by the German government, for being "shameful, pornographic, and sexist." They had deduced that I was assigned female at birth, and therefore my chiseled chest was actually pornographic breasts. With this essentialist, binary viewpoint, the poster was removed to protect the public from its "shamefulness."

Contrary to popular hysteria, which considers the presence of trans people to be a threat, gender-nonconforming people, especially those of color, are extremely vulnerable to becoming the victim of attacks. Art is vital to the project of working against transphobia, and the recent attempt to ban my images from the public sphere only underlines their necessity.

To quote writer, philosopher, and curator Paul Preciadio, "I do not want the female gender that was assigned to me at birth. Neither do I want the male gender that transsexual medicine can furnish and that the state will award me if I behave in the right way. I do not want any of it." Even before this pandemic, my mind was reeling. The world seems upside down. As an antidote, I return to art as a strategy to invoke rituals of both the sacred and the profane. I draw solace from the words of Susan Stryker, who recently wrote, "If anti-trans discrimination is the worst thing that has ever happened to you, remember that there are others

here today whose people have survived occupation, slavery, genocide, and holocaust; learn from the traditions and history of the oppressed."

The exhibition *Solutions*, which took place from 2018 to 2019 at the Station Museum of Contemporary Art in Houston, pulls inspiration from the long legacy of artists who have come before me and is anchored by such sentiment. We have always been around, and our legacies are ancient. Amid the raging culture war being waged, *Solutions* mobilizes the interior architecture of the Station Museum of Contemporary Art, an exhibition space modeled after the Greek Temple of Athena, Goddess of War. Currently, the rhetoric of "religious freedom" is being used as justification for curtailing the civil rights of minoritized groups. What if the constitutional right to religious freedoms were invoked to protect a religion where our deities were brown people, Muslims, women, queers, and indigenous folks? What if to harm such a body was framed not as the quotidian victim of police brutality, xenophobia, or transphobia, but as an act of religious persecution?

Would the sanctity of our lives finally be given value?

This idea became the inspiration for the *Solutions* exhibition.

PISSED (2017), a minimalist sculpture in the form of a glass cube containing more than 200 gallons of urine and initially collected between February 17 and September 16, 2017, made up the altar of the exhibition. The material was a collection of all fluid my body had passed since the last administration rescinded an Obama-era executive order allowing transgender students to use the school bathroom matching their current gender identities versus the sex they were assigned at birth. I continued this performance for 200 days. Over the 4,800 hours that my performance of *PISSED* manifested, I made my protest visible daily and refused to allow the issue to recede from view. The work was a daily disruption of the public spaces through which I moved over the months of urine collecting. Every day, everywhere I went, I carried a twenty-four-hour

urine capture container in a cooler bag on ice. In the end, much to the dismay of my wife, I had filled six full-size fridges.

The presentation of the end sculpture, a gallery-based work, must be understood as the result of hundreds, if not thousands, of daily conversations that accrued among friends, strangers, colleagues, authorities, and acquaintances. My labor for the work included shouldering these conversations, again and again, as well as enduring the visibility that this performance brought to me, my body, and its processes. As I traveled outside the country for thirty days, and could not bring my urine across international borders, I asked friends to donate their urine in my absence—after all, this is not about my body, it is how much *a* body has to contend with, as a result of an oppressive ordinance. Often these people were cis gendered and asking them to participate hyperperformed an otherwise private bodily function.

In the remounting of *PISSED* (2018) at the Station Museum, all urine was donated by the citizens of Houston, cis and trans alike, through a "urine drive" in an act of solidarity. The collecting of the urine transpired throughout the entirety of the exhibition from November 3, 2018, until the closing on March 3, 2019. The goal was to reach 654 gallons, which represented the 654 days that have passed since the ordinance was rescinded. Remounting the work in Texas imposed a powerful visualization of the literal burden that the 2017 repeal inflicts on vulnerable trans children. Functioning as an index of what a body passes in relation to a government ordinance over time, the tank of glowing urine formally manifests what may seem abstract in discussion: the very real content of bodily fluid being regulated by a discriminatory administration.

The *PISSED* sculpture is contextualized by a four-channel audio installation made of recorded testimonies from the Gloucester County School Board in Virginia, where concerned parents, students, and faculty share opinions about the use of men's bathroom by fourteen-year-old transgender activist Gavin Grim. Throughout the two-hour sound piece, we follow Grim's case all the way, from these classroom teacher dialogues to the Fourth Court of Appeals. The sound component articulates the ignorance and biases that run through every level of the judicial proceedings. I separated the oral arguments and spaced them over

four speakers, showing these adults arguing over a child's body. As they loop, I slowly submerge the arguments underwater, linking the audio to the fluid in the room. March 31 is the International Transgender Day of Visibility, yet visibility alone will not keep transgender youth safe.

At least twenty states are currently [in 2021] considering thirty-one bills that would attack the rights of transgender people, mostly youth, as more lawmakers file bills to tear away at the limited rights and protections that currently exist for transgender individuals. Arizona, Connecticut, Iowa, Georgia, Hawaii, Kentucky, Minnesota, Mississippi, Missouri, Montana, New Hampshire, North Dakota, Oklahoma, South Carolina, South Dakota, Texas, and Tennessee are all considering bills that would ban transgender girls and women from school sports. Some of the bills also ban transgender boys and men from competing as their gender. Eleven states are also considering bills that would ban gender-affirming care for transgender minors, even attacking puberty blockers, which must be taken before a person is an adult in order to be effective.[1]

In 2010, I made the performance *Tiresias*, and at the time there were no terms like *nonbinary* or *gender fluid*. There was little representation of gender-nonconforming people, and even within the trans community there was pressure to adhere to the gender binary. Unless you embraced a full medical transition, you were suspect by both the trans community and especially the cis-dominant culture. In Greek mythology, Tiresias is the blind prophet of Thebes who is famous for being transformed from a man into a woman for seven years. In this work, I embody Tiresias by pressing my body up against the back of a neoclassical Greek male torso carved out of ice for precise contact with my physique. I melt the ice sculpture with pure body heat, performing the resolve required to persist at the point of contact between the masculine and feminine.

For the opening of the show in Texas, I made a collaborative work called *Solutions* two days before the US midterm elections. This was a performance that used *Tiresias* as a jumping-off point. I invited Rafa Esparza, Fanaa, and Keijaun Thomas, artists whose subject positions

1 To learn more about anti-trans and anti-LGBTQIA bills, see the LGBTQ rights legislative tracker of the American Civil Liberties Union (ACLU), aclu.org/legislation-affecting-lgbt-rights-across-country.

differ but whose civil rights are all being eroded by the current US administration. Together, we expanded and reimagined *Tiresias*, incorporating their performing bodies, all of us working with the medium of ICE, which also stands for Immigration and Customs Enforcement. The performance spoke of the coming together of divergent expressions, the power of performative actions, and the generation of collective creative forces. I made four films, one for each artist as they worked with their chosen symbol carved out of ice. These films were installed to formally reference the classical sculptures of divine figures found in temples of worship. In the performance, against the backdrop of these films, we four artists collectively melted a column of ice, shifting the frozen obstacle from body to body, placing our warm flesh between the ice and the body of another as one started to shake uncontrollably from the cold.

Together, we scrubbed this barrier, licked it, rubbed it, humped it, and stroked it until it melted, the collective runoff flooding the gallery floor.

This mindset also inspired the collaboration for MoCA Tucson called *Cyclic* (2018), my newest collaboration with artists Ron Athey and Fanaa. This piece took place at the Biosphere 2, on December 1, 2019, World AIDS Day. Since the show was grounded in religion and spirituality, I thought it would be interesting to work with artists who had various relationships with the subject and who could speak to the cyclical nature of oppression. Against the surreal context of the Biosphere 2, a site that

was initially a utopian building with the lofty goal of space colonization and which now presents itself as a dystopic option for a world crumbling under climate disaster, the collapsed lung seemed like an apt stage for exploring our death rites.

Cyclic is a cannibalizing of all our practices, interweaving elements from each of our past works with the new discoveries that come from collaboration. I wanted to work with Athey, a mentor who lived through and survived the AIDS crisis. I came of age as an artist under the shadow of this plague, before the internet, and when there were no trans or queer artists whose work I could access. Working with Anthey was a way to examine these cycles of oppression by having him reperform, as part of *Cyclic,* the controversial *Human Printing Press,* a work that had not been performed since 1986, at the Walker Art Center. Back in the day, this work forced the conversation about HIV-positive bodies on to the art world. Carving into the back of performers and hanging their bloody imprints above the audience was guilt by association. The work posed the question: whose bodies were deemed worthy of saving and whose were disposable?

The media frenzy surrounding this work led to conservative senator Jesse Helms pulling the plug on individual artist funding, commencing a long-standing gag order on artists. In the US Senate, Helms snarled dismissively, "Do you want your tax dollars funding this filth?" just as thousands of queers—artists and citizens alike—were left to rot due to the negligence of the Reagan administration. By incorporating this work into *Cyclic* on World AIDS Day, we are recognizing the intergenerational passing and recognition of the invisible burden of queer survival and struggle often unknown by the younger generation.

Fanaa and I worked together in many capacities over the years. She works across various media, including film, visual art, performance, and sound. Her work explores themes of embodiment and mysticism, particularly within the Islamic Sufi context, and stems from the complexities of inhabiting multiple personas: woman, Muslim, immigrant, citizen, insider, and outsider. She challenges and celebrates the socio-cultural and religious iconography she was raised with and works with the kaleidoscopic varieties of aesthetic expression in the Muslim world that are marginalized both within conservative Islam and the Western

imagination. In *Exhumed* (2018), Fanaa is buried under soil for nearly an hour as the sound of a subterranean drone unravels into a reverse playback of a Palestinian lullaby by the late singer, composer, and activist Rim Banna (1985–2018). In the performance, Fanaa is dragged out of the earth by two men in an act somewhere between an exhumation and a birth. She performs an Islamic cleansing ritual usually done with water, but in times of drought soil can be used. Her gesture links her body to the cyclic history of violence against women's bodies: the unmarked graves, the missing women of Juarez, the earth works of Ana Mendieta, which speak to being forced from one's homeland, migration, refugee status, the outline in chalk of the vanished corpse, and the connection to Mother Nature, which knows no borders. Fanaa gathers the earth of her burial into a large sack, struggling to drag it with her, invoking the Greek mythological sorceress Medea's action of carrying the soil of her homeland wherever she goes.

For my part, I created *PRESSED*. Anticipating Anthey's printing press action, I chose to shadow his action by working with the precarious medium of glass. Triangulated between Fanaa's unmarked grave and Anthey's cutting station, I lie on the metal floor of the lung, the temperature of the room near freezing, and with a one-hundred-pound thick rectangular glass placed upon my prone body. I have been thinking of many things of late, discussing with my friends our attempts to put a positive spin to it despite all the oppression, misogyny, transphobia, systemic racism, xenophobia, and children held in cages in detention centers. Sometimes there is no positive. We have to hold in our hands a broken unjust world along with a "living as usual" attitude until we hack the problem. This piece was manifested in a moment of hopelessness.

Artist Alok Vaid-Menon's words resonate when they talk about the pressure and the double-edged sword of visibility: "Rather than strategizing against public harassment, the LGBTQ movement has conceded that we have to conform to a gender binary to be safe. I talk about harassment and then I get harassed."

Visibility is traumatic. It is exhausting. It is the opposite of a party.

No, it's being at the party and watching people celebrate the victory you have never felt. It's being the only one who looks like you, not by circumstance but by design. It's a Pride catalyzed by gender-nonconforming trans femmes that continues to push us out. This is what it means to be out? Not to be free but to be made a freak. Are you a girl or a boy? I said I am both." I feel you Alok, as I heave this 100-plus-pound untempered glass pane with every ounce of my strength, the sweat emanating from my body caused by the blaze of the spotlight from the collective of bodies crammed into this intimate self-anointed gallery, knowing full well that if I drop it, I will hurt not only myself but everyone around me watching.

Up to and Including Their Limits (2020), a work I made weeks before lockdown and which now eerily foreshadows our present moment, was shown at the Gardiner Museum in Toronto. This work extends the legacy of the late feminist icon Carolee Schneemann's historic piece *Up to and Including Her Limits* (1971–76) and brings it to a trans nonbinary perspective. Schneemann developed her own approach to art making in dialogue with action painting, seeking to insert her own body and her own perspective into a historically male-dominated arena. In many ways, *Up to and Including Their Limits* is a prequel for my most well-known piece, *Becoming an Image* (2012–present). In this work, I unleash an attack on a 2,000-pound clay block, delivering a series of kicks and blows in total darkness. The spectacle is illuminated only by a photographer's flash, which burns the image into the viewer's retina. I initially performed *Becoming an Image* at the ONE National Gay and Lesbian Archives at the University of Southern California, which houses the largest collection of LGBTQ materials in the world. Striving to problematize and complicate the very act of documenting itself, this performance points to the evidence of queer and trans lives that are often missing from historical

representation. All the darkness and lived experiences become momentarily visible in between the flashes and outside the realm of statistical notations.

In *Becoming an Image*, the photographer is doing so much more than simply "documenting." He is very much part of it and becomes an instrument of light. The interaction between us undulates from moments of pure symbiosis to power struggles. We enter into a blind dance in the pitch darkness, our relation to each other made evident by the digital instrument, the sounds of our footfalls, and our collective breath. The result of these performances is a series of amorphous clay sculptures, standing in for bashed bodies, marked with the imprint of fists, knees, elbows, sweat, and struggle.

At my 2019 solo exhibition at the Institute of Contemporary Arts in Perth, Australia, I asked the photographer to turn the camera on the audience. The night after the performance, he and I worked into the next morning, creating site-specific wallpaper of the audience members' reactions to the live event. The performance photographs, taken blind and at random, were then hung over the audience-member wallpaper, and when the same people, who had come to the performance the night before, came back to attend the exhibition the next night, they were to find their own eyes gazing back at them. This is my way of carrying forward the ethos and red thread of the idea, which germinates in the live action into an installation, extending the work to those who are not present for the performance. Presenting the elements in this way, I triangulate the viewers, the performer, and the camera by folding their gaze into the work itself.

I DO NOT
BELIEVE IN THE
PASSIVITY OF
AN AUDIENCE.
NO ONE GETS
TO STAND ON
THE SIDELINES.
IF YOU ARE A
WITNESS,
IT MEANS
YOU TOO ARE
PRESENT,
ALIVE, AND
ACCOUNTABLE.

I have cast the bashed remnants from *Becoming an Image* into durable sculptural materials. There is a concrete cast, a bronze, and with continued support, I want to pour a porcelain cast. These traditional sculptural materials will offer historical weight and preciousness to lives often deemed disposable. With support of a Creative Capital fellowship, I proposed to turn these sculptures into public monuments on view at the sites where acts of violence had occurred against trans and gender-nonconforming people. But having funds to make only two monuments raised the question: How to choose a site when there are so many occurrences of violence? And in choosing to commemorate one history, what other histories are you omitting? Rather than keeping the sites static, I decided instead to mobilize the monument.

In April 2017, I launched the world premiere of *Monument Push* at the Bemis Center for Contemporary Arts in Omaha, Nebraska. Often deemed "flyover country" by "blue" coastal states and located in the heart of "red" America, the Bemis Center and I worked in partnership with members of the LGBTQAI+ community along with allies and advocates to choose sites that sought to explore spaces of trauma, violence, celebration, resistance, and resilience. One of these sites was the largest prison in the Midwest, a site chosen by Dominique Morgan, a local activist and acclaimed singer and songwriter who is deeply entrenched in advocacy for community and youth. She chose this site because LGBTQAI+ youth of color are particularly at risk for arrest and detention.[2] Similar to how transgender adults are often placed into solitary confinement, allegedly for their own protection, these youth are "protected" in the same way. Morgan was put in solitary as a teen because she was an out gay young person—the prison's solution for protecting her against possible rape. One of the most moving moments of the procession came when the crowd gathered in front of the prison. Dominique took a break from

2 Nearly one in ten prisons in the United States are privately owned. The Center for American Progress found that each year approximately 300,000 gay, trans, and gender-nonconforming youth are arrested or detained, 60 percent of whom are Black or Hispanic. Jerome Hunt and Aisha C. Moodie-Mills, "The Unfair Criminalization of Gay and Transgender Youth," The Center for American Progress, 29 June 2012, bit.ly/gay-trans-youth-criminalization.

pushing to softly perform a song she had written while confined there in her youth. When she raised her voice for the refrain, it echoed off the walls of the prison, amplifying her personal pain and trauma. This song is the main through line for the video document.

In the summer of 2020, California was smoldering, and against the flames and toxic air levied by fire and the burning uprisings, a collective of artists and I summoned the spirit of the late Black pioneering writer Toni Morrison, who prophetically wrote, "There is no time for despair, no place for self-pity, no need for silence, no room for fear. We speak, we write, we do language. That is how civilizations heal."

Artist Rafa Esparza and I came together to make a work called *In Plain Sight* (2020), as hundreds of thousands of Americans were protesting the policing of daily life, especially among the Black communities and communities of color, and a dangerous immigration policy. The system criminalizes, incarcerates, and deports people, separating families and loved ones forever and depriving them of their liberties. I was motivated to make this new work as a trans person who has navigated the US immigration system. During my own seventeen-year fraught path to citizenship, I have glimpsed firsthand the unjust, meritless, financially motivated, bigoted, and dehumanizing nature of the US immigration system. Fairness, freedom, opportunity, and respect for human rights should be at the core of our immigration system. But our country is not set up to uphold these values. Racism is at the root of many of our systems in the United States, designed to strip people of their dignity, and the U.S. immigration system racially profiles and targets people based on the color of their skin. To quote Patrisse Cullors, one of the *In Plain Sight* artists and cofounder of Black Lives Matter: "One cannot say Defund ICE without saying Defund the police."

It is against this backdrop that Esparza and I began working on *In Plain Sight* with a coalition of eighty artists who are united to create innovative and poetic artwork dedicated to the abolition of immigrant detention and the United States culture of incarceration. The artists who participated come from a vast array of ages and reflect established and emerging voices, artists who have been detained, are undocumented, are indigenous, are descendants of survivors of Japanese American incarceration, the Holocaust, and the afterlife of the AIDS crisis. Though

differing wildly in subjectivities, in an act of solidarity these artists came together to focus their attention on immigrant detention.

We made this work after the discovery of how many of these immigrant jails exist in the United States. There are over 200 of these prisons, and they are in every state, not just the border states. Over July 3 and 4, 2020, Independence Day weekend, *In Plain Sight* launched the nation's sky-typing fleets, with a carbon offset plan, to spell out artist-generated messages in water vapor, legible for miles. These messages were typed in the sky over detention facilities, immigration courts, borders, and sites of historical relevance. Our goal was to make visible the hundreds of detention facilities by launching a national sky-typing campaign in which we could harness people's attention toward our website, which also functioned as a tool to help educate and engage the masses to take action. Our strategy was to amplify calls to action from our coalition of seventeen immigrant justice organizations, to fund local bond funds used to help get folks out of detention while they fight their case from the outside, and to encourage people to vote. We wanted to ask everyone to use their vote and to consider this crime against humanity.

As the planes soared, they made visible in the sky what is too often unseen and unspoken on the ground—the appalling and profoundly immoral imprisonment of immigrants. *In Plain Sight* broke through this wall of secrecy, using art as public engagement to expose and scrutinize the sites of detention centers. Our art activation was distinguished by working with a social impact team that specializes in community partner engagement. They worked with the boots-on-the-ground organizers as we worked with the artists in the sky to make an artwork that ultimately serves the missions of the immigrant rights advocates.

We did not want to make a work about immigrant detention—we wanted

to use art to elevate the work of our partnering organizations and pierce through the rhetoric to move people into action.

We worked with our lead impact producer, Set Hernandez Rongkilyo, a nonbinary, undocumented immigrant filmmaker and community organizer whose roots are in the Philippines. Their work is rooted in the belief that cultural strategies can propel political transformation. We also worked with Lina Srivastava, a social innovation strategist, working at the intersection of social action, interactive media, and narrative design, and Becky Litchenfeld, a human rights advocate, producer and director of social impact media for the Bertha Foundation, which supports forms of activism that aim to bring about change and champions those using media, law, and enterprise as tools to achieve their vision.

The impact team was guided by the belief that media and the arts can play a vital role in the advancement of human rights. As the planes soared, we had twelve on-the-ground activations. We flew over Mesa Verde Detention Center in Bakersfield, typing out Harry Gamboa's message: NO ICE NO ICE NO ICE; those incarcerated had their yard time and started to collectively chant. There was a protest outside the detention center, and they too joined the chant. The sound of their reverberating voices reached the immigrants in solitary confinement who were being punished for starting a hunger strike in solidarity with Black Lives Matter. They too heard the chant, and this cemented their conviction to continue their struggle. Each sky-typed message was followed by the hashtag #xmap, and upon searching on Instagram or the web, one would be

driven toward our site Xmap.us[3] where you can access an interactive map that tells you where the nearest detention centers are in your vicinity. The website continues to provide calls to action and other ways to help change the lives of those who are immorally and unjustly detained.

A single sky-written message over an urban center on a clear day can reach 3 million people. With eighty messages in the sky, we brought this issue to 24 million people nationwide. We had over 150 pieces of press, over 100,000 shares on social media, and more than 3.54 million in readership from our recent action. We used art to reach and educate a lot of people. *In Plain Sight* is the radical idea that despite lockdowns, plague, systemic racism, and the slashing of arts funding, we as artists have the power to create coalitions and possess the agency to create self-produced and self-determined grand visions for change. Our vision is centered on love, community, and relevant action, and not in fear and division.

I could never have predicted that there would be such openly hostile and very dangerous executive orders and that the US president from 2017 to 2021 would be as sociopathic, narcissistic, and incompetent as he was. Who could have imagined all the myriad of hard-fought rights that were rolled back, let alone all the Covid-19 deaths that could have been avoided? Or the insurrection, where white supremacists flew the Confederate flag in the Capitol Building, followed by an inquisition that saw US senators, despite clear evidence that there was incitement of a violent mob, not voting to convict a corrupt president out of concern for their own seats. But then, we could also not have predicted spontaneous protests at airports and the stunning number of women out there protesting around the world or the act of football players taking the knee to ignite a discussion about racism in America, the successes of Stacey Abrams and an incredible network of tireless organizers in the south, Georgia turning blue, the sacrifices of our medical staff, the dozens of friends who spent countless unemployed hours sewing masks in the beginning of the pandemic or those working on the front lines because they could not afford to stay in quarantine.

3 *In Plain Sight*, https://xmap.us.

There is a struggle for and a struggle against.

This world is changing around us more than ever before. It is shifting, and it is up to forward-thinking people, citizens, students, faculty, artists, and art administrators like ourselves to be part of what this shift is crafted into. Despite the injustice and corruption, remember that the actions you take today seek conviction for the record books, a conviction for history. This is a time in history that will be long studied. The questions remain: What is at stake for yourself and others? What can you do? What did you say? What art did you make? How did you act? What is your conviction?

I will conclude by reading a hopeful quote from the late New York–based, Cuban-born scholar José Esteban Muñoz:

> Queerness is not yet here. Queerness is an ideality. Put another way, we are not yet queer. We may never touch queerness, but we can feel it as the warm illumination of a horizon imbued with potentiality.
>
> We have never been queer, yet queerness exists for us as an ideality that can be distilled from the past and used to imagine a future.

Q&A

I was reading an article where your work is described as coming from a place of rage. It is palpable in your work. For instance, how you describe PISSED *made me think about how you also use your body as a purging vessel. Where does the rage begin, and does it ever end? And how can the body heal?*

Q

A There is rage but it is more a sense of injustice. Being an artist is a sort of last bastion and slice of agency. We have the ability to be creative and generative, we have the ability to use our body, and through that slice of agency there is a way to transmute or take whatever is happening in the world and press it through my body as a way of feeling a sense of agency in expression. Sometimes that is anger, and the earlier works are very much about smacking people in the face, forcing us out of simply witnessing and asking for people to wake up. In later works, like *Monument Push* and *Becoming an Image,* I fold in the community in the making of the sculpture and usher the audience into the space. It is a collaborative process where we bring the community together. It is through this act of solidarity and togetherness that we are able to express rage but also express tenderness and support. *In Plain Sight* is located in outrage but is also this incredible opportunity for bringing so many different people together. Though I was co-lead in this piece, I want to emphasize that this is a work that involves hundreds of people. It was this multitude of voices from diverging expressions being elevated in the sky and speaking together. It speaks to a collective rage while demonstrating the possibility of

what can be done when we bring our voices together to express very complicated and nuanced experiences of injustice. We speak from an authentic space in order to support each other. That use of rage is actually incredibly powerful and healing because it allows for artistic kinship and using our creative force to create change.

How can cultural strategies impel political change? Do art and culture have special capacities in that regard? Do they do it in a particular way that is different from other comparable strategies such as teaching litigation and legislation?

Q

A

I don't see it as an either/or. We are all siloed into our different disciplines, and there is not a lot of cross-pollination. There is a very particular aesthetic to activism when it comes from grassroots organizations who do the groundwork; but their work is not necessarily focused on the visual aspect, so how can artists bring that surprising visual intervention? How can we use our imaginations to collaborate and support?

What was so exciting about working on *In Plain Sight* is that our impact coordinator was able to draw these lines between seventeen different immigrant justice organizations, many of which were doing corresponding and complementary work and had never been in touch with each other. It offers a whole different level of contribution, and there needs to be more nodes of connection where we can bring these dialogues together and support each other's visions.

EMILY JOHNSON

LAND AND AN ARCHITECTURE OF THE OVERFLOW

April 9, 2021
Emily Johnson, Lenapehoking (New York City, USA)

Moderator
Christian Ayne Crouch, Dean of Graduate Studies;
Associate Professor of Historical Studies and
American Studies, Bard College

Photo by Tracy Rector and Melissa Ponder

INTRODUCTION

Christian Ayne Crouch

As part of the Center for Human Rights and the Arts talks by artists and activists, Yup'ik Nation artist, choreographer, director, and writer Emily Johnson will be speaking on "Land and An Architecture of the Overflow." Today's talk is especially exciting to me, as someone working in the field of Native American and Indigenous studies.

Today, Emily Johnson is our teacher and the exemplar of the work so many of us must be doing. We learn from her, from her practice, from her voice, from her generosity. She is a land and water protector, and her very words, "We are the intermediaries between breath," affirm the urgency of finding restorative connection that flows through her body-based work as an artist and her activism around questions of sovereignty and well-being that she has engaged in for more than two decades. Her focus on bodies, when she describes "our bodies are culture, history, present and future, all at once," demands that we all need to be engaged in the processes of remaking our relationship to this earth that nourishes us.

Collaboration has been at the center of many of her recent performances. It emerged last September at Jeffrey Gibson's installation, *Because Once You Enter My House, It Becomes Our House* (2020), at Socrates Sculpture Park, where, in her location-specific choreography, she showcased pathways for regeneration, renewal, and transformation. Collaboration is embedded in her role in developing a First Nations Performing Arts Network and in the monthly ceremonial fire she leads

in Lenapehoking, on the Lower East Side of Mannahatta, in partnership with Karyn Recollet and the Abrons Arts Center. She is the recipient of numerous prestigious awards, including a Guggenheim Fellowship, a Doris Duke Artist Award, and a Bessie Award for choreography, all of which attest to the immediacy and the necessity of her work and presence in formal ways.

LAND AND AN ARCHITECTURE OF THE OVERFLOW

Emily Johnson

It is a real pleasure to be here with you and to share with you some new articulation, some new thinking, so I hope you are with me in the newness of it. I am here in Lenapehoking at Abrons Art Center on the Lower East Side of Mannahatta. It is an honor to live here and to work here, and I send my gratitude and give deep thanks to the Delaware Tribe of Indians in Bartlesville, Oklahoma, the Delaware Nation of Oklahoma in Anadarko, Oklahoma, the Stockbridge-Munsee and Mohican community in Wisconsin, the Moravian Delaware of the Thames, the Munsee Delaware Nation, and the Delaware Six Nations all in Ontario, Canada, now since their forced removal from here, their homelands. I hope my work in dance making and with institutions, organizations, and individuals is on a path toward homecoming in the ways that Lenapeyok want to, desire to, need to return home.

I am going to share this new work with you, and it feels very odd because I cannot see you [in this webinar], and I still rely on that energy back and forth, but I am going to trust you are there. Go ahead, take this in how you want to: sitting, lying down, or moving around, with your eyes closed or open. I just thank you for being here:

Land and An Architecture of the Overflow

We are the intermediaries between breath. Between air space. Between those who can breathe and move and those who cannot anymore.

Emily Johnson, a Yup'ik womxn, performs on a pink and blue sculpture at night.

Someday the civil rights and sovereignty of Indigenous peoples will be recognized in relation to land.

+

She is crouched low on one leg; the other leg is reaching beyond the edge of the sculpture and into the air. She is gesturing with her arms, and her hands frame her face. Her head is reaching up, and it seems she is telling a story—her eyes are closed.

Someday power imbalance and extraction will not be the default relationship in our working lives. Someday the theft of and abuses on and lack of recognition of Indigenous land and water will not be tolerated.

+

Marsha. Sylvia. Alexandra. Aliyah. Marione. Vivian Sula. Bella Marie. Yvonne. Jade. Tabitha. Mariella. Anna. Breonna. Tony. Muhlaysia. Beelove. Ashanti. Bailey. Nina. Monika. Layleen. We are not conjuring them. But we are conjuring joy of them. Offering it again and again, in respectful remembrance and protection. Until no more are taken from us.

She is wearing a short bright blue jumpsuit which has a low cut V-neck, and brown work boots. Her hair is down and somewhat wet from sweat.

+

Land is in the hands and the knees. It curves behind and spirals upward. A softness exudes. When I jump on you, you hold me. How do we resist the notion of ground, under? When in real physical form, land is under ... often. Karyn Recollet asked if we breathe rock dust but used a different term. Joseph Pierce and I said yes. Dust, city, construction, stomping. So, land, internal, too. Physically, inside. There are more directions and we still have gravity to contend with. How it creates a down and an up. I have moved all my cells in a focused attention. When I stomp, I think of the ground lifting with me. This is the closest to flying I have come.

This rising stomp. This vibratory lift: the stomp is *after* the sound, the impact, the land. The space is in between: possibility, otherwise.

Someone I dance with, Stacy Lynn Smith, is grabbing bits of that rock stardust. Jolting the land with their elbows. A circumference around themselves, bigger than themselves. We shut our eyes when we want to go further. We, meaning dancers, I guess.

This is me, making this dance:

We.

are the intermediaries between breath. Between air space. Between those who can breathe and move and those who cannot anymore.

We are not conjuring them. But we are conjuring joy of them. Offering it again AND again and AGAIN, in respectful remembrance and protection.[1] Until no more are taken from us.

I need you to remember.

Please, if it is necessary, shut your eyes.

Inhale *(deep breath)*.

/

That air.

Marsha. Sylvia. Alexandra. Aliyah. Marione. Vivian Sula. Bella Marie. Yvonne. Jade. Tabitha. Mariella. Anna. Breonna. Tony. Muhlaysia. Beelove. Ashanti. Bailey. Nina. Monika. Layleen.[2]

1 Emily Johnson, "Then a Cunning Voice and a Night We Spend Gazing at Stars" in *Love and Fury* by Sterlin Harjo, ARRAY Releasing: Los Angeles, CA, 2019, Video.
2 Emily Johnson, "The Ways We Love and The Ways We Love Better—

I need you to remember when they were breathing.

/

To be explicit. These are missing and murdered Indigenous women, girls, trans, and two-spirited people, these are Black women, Black trans women, all womxn who have been killed in the ongoing genocide and extraction of women, femmes, and two-spirit relatives from Indigenous land.

"We don't have a climate crisis. We are experiencing the centuries-long consequences of settler colonialism and racial capitalism." Sandy Grande said that in the opening to "Good Relations: Native Scholars and Artists on Climate Justice" (2021), a panel hosted by UCONN Humanities that Sandy invited me, Melanie Yazzie, and Anne Spice to share space in.[3]

"We don't have a climate crisis. We are experiencing the centuries-long consequences of settler colonialism and racial capitalism."

Karyn Recollet[4] has been leading me from ground to celestial-ness. Star-land-ings become raging inside my surface, underneath my skin. *Earth might fall from my feet, my hands. There is sound here, reverb. The rising stomp. Exchange, an underneath. The vibratory lift. Their names rip through me, I breathe beyond the capacity of my lungs, some people call this endurance. And I meet it—Endurance,* again AND again and AGAIN;[5]

Monumental Movement Toward Being Future Being(s)," Socrates Sculpture Park, 2020, bit.ly/emily-johnson-socrates.

3 "Good Relations: Native Scholars and Artists on Climate Justice," University of Connecticut, panel discussion, 1 April 2021, bit.ly/good-relations-panel-video.

4 Karyn Recollet, University of Toronto, wgsi.utoronto.ca/person/karyn-recollet.

5 Emily Johnson, "Then a Cunning Voice and a Night We Spend Gazing at Stars" in

Their names rip through me.

One day, civil rights and sovereignty of Indigenous peoples will be recognized in relation to land. Power imbalance and extraction will not be the default relationship in our working lives. Theft of, abuses on, and lack of recognition of Indigenous land and water will not be tolerated.

As some of you may know, I have written a long letter recently, one that I hope in the future doesn't need to be written.[6] I encourage you to read it.

I am a dance maker. I make large social gatherings. I think of performance as offering and in continual effort to build relations between and among us humans, our more-than-human kin, and the land, water, celestial places we are gathered on and in. With my dear colleague and sister Karyn Recollet, whom I have already named,

we think with a kinstillatory praxis; a choreography of relationality, a technology to spatially orient a collective to think, dream, activate community.[7]

Love and Fury by Sterlin Harjo, ARRAY Releasing: Los Angeles, CA, 2019, Video.

6 Emily Johnson, "A Letter I Hope in the Future, Doesn't Need to Be Written,"
 Medium, 21 February 2021, bit.ly/does-not-need-to-be-written.

7 Emily Johnson and Karyn Recollet, "Kin-dling and Other Radical

To honor what I know is possible, and to create paths for a reworlding that centers justice and equity, the dances I make need to be in relation with world and land. The making of them is not separate from performing them. These dances create and celebrate the making of community—inviting participants and audiences to gather in shared action. Sometimes this shared action is visioning, voicing an overflow: What do you want for your well-being? For the well-being of your chosen friends and family? For your neighborhood, city, community, world?[8] From the collective visioning, other actions rise: planting trees and shrubs to shore up dunes on the Rockaways in Lenapehoking; rewilding gardens at Daybreak Star Indian Cultural Center on Duwamish land; daylighting a stream with artistic intervention leading to Tuggeght beach in what is called Homer, Alaska; sewing a healing possum-skin cloak with womxn and Elders in Narrm; making 84 quilts in community sewing bees across Turtle Island; centering food sovereignty and labor in public feasts.

This work strives at all levels to center Indigenous thrivance—because, we thrive—and to counter perceived invisibility of Indigenous people and culture through recognition, acknowledgment, and relationships with land, other beings, and people. With settler-run institutions and partners, this means decolonization and Indigenization processes on a structural level.[9]

Karyn and I are writing this paragraph: "This making and this matter that comes. An invitation to alternative forms, ways of moving tentacularly, as Julie Burelle has named, that nourish the kinstillatory as we reach into different shapes of gathering: resonance, overflow. There are no prescribed lines here, no circles per se, but processual gatherings of care and protection that become portals into an otherwise space-time. This otherwise, a reflection of Ashon Crawley's work."

Relationalities," *Movement Research Performance Journal: Native Dance, Movement and Performance*. Fall 2019, Issue no. 52/53, bit.ly/kin-dling.

8 Emily Johnson, *SHORE*, 2014, catalystdance.com/shore.

9 Sandy Grande, Jackson Polys, Emily Johnson, and Jane Anderson, *From a Decolonial Action Perspective*, 17–20; *Notes on Equitable Funding from Arts Workers*, Creating New Futures, 2021, bit.ly/creating-new-futures.

I have asked us to do this, travel through space and time, to be in two places at once. It is part of how we relate to land, and the stomp, and the GATHER HERE.

I am holding a sign above my head. It says GATHER HERE.

These dances I describe choreograph intention and accept these alternative shapes of gatherings, these actions, guided conversations, pointed stillnesses, and time together as forms of radical relationship, as overflow, as a multitude of places where all things are possible, and as methods to create present-futures we envision—present-futures that include relation with past as well as with generations not yet born.

The overflow is resonance, moving in the in-between, in-the-collective, in-the-invitation to GATHER HERE. Can the overflow become supported, beyond the moment of the performance gathering, a speculative architecture resisting BUILD, but living, ongoing in an otherwise?

So much love and gratitude to IV Castellanos and Karyn Recollet, Joseph M. Pierce, Camille Georgeson-Usher,[10] Dylan Robinson, Jane Anderson, Nicole Wallace, Collete Denali Montoya-Sloan, Yanira Castro, Joe Whittle, River Whittle, Melissa Shaginoff, Drew Michael, Raven Chacon, Holly Nordlum, Amber Webb, and the work of others not named explicitly in this reading, with whom I cherish thinking and being alongside and with.

/

I have been walking the circumference of the outer-branch spread of trees. My colleagues notice how the tree is organizing me. I am trying to pay attention with all of my senses and cells. It becomes curious to think we are the activators, we are the designers, that we even know

10 Karyn Recollet, Joseph M. Pierce, Camille Georgeson-Usher, and Emily
 Johnson, "Responsive Witnessing: STTLMNT Digital Occupation Project,"
 Broken Boxes Podcast, 2021, bit.ly/responsive-witnessing.

when something begins or ends. Is the tree moving me? Dylan Robinson asked me this.[11]

Walking the circumstance of the circumference, we notice we are walking the circumstance of the circumference of the roots too. We find here an energy cypher that roots itself as a tickling in our bellies, a flowed sensation that is around the entirety of our belly and our back, and the root of self—perhaps similar to the full roundness of a tree trunk. The teaching from the tree is that this is a way to comprehend the entire STRUCTURE, if not the full BEINGNESS of the tree. Structure is not, in this moment, next to or touching the trunk, or the tree, or the bark. The closeness actually exists in this otherwise space that aligns tip of top reaching branch space to tip of underground reaching, spreading root space. Root as branch and branch as root. Moving along the energy space of the cypher that simultaneously reaches up and reaches down, along the path of the root/branch spread is vital. A learned process of decolonizing outside space, walking over or across the buildings makes sense and lessens the "matter" of the buildings—they become and are less important, less material, less permanent than this cypher space of and with the tree.

When I am *inside* I am always thinking of the ground *underneath*.

The rising stomp, an invitation to a reorientation.[12]

/

I perceive change and future as coming from inside. Inward. Within. As in, it is something we make, meet, determine. Is the collective inside a place we can gather to create an outward together?
So, an invitation to GATHER HERE.

11 Emily Johnson / Catalyst, "Inside the Pillow Lab: Emily Johnson," bit.ly/pillow-lab.
12 Emily Johnson, "Rising Stomp," Artists-in-Presidents, 2021, artistsinpresidents.com/emily-johnson.

How do our cells become oriented to justice?

What if, as Karyn Recollet and I spoke of recently, we insist an ethics of non-extraction?

What is it to know whose lands you occupy? What is it to change how and if you do?

"The Letter I Hope in the Future, Doesn't Need to Be Written," *was* written, so that we, *artworkers, audiences, presenters, funders, and a broader public*, can examine what exists. So we can build processes and relationships forward that are equitable, justice centered, and decolonized, rather than stay in systems and experiences that perpetuate violence and extraction.

The letter was written about one person's experience, mine. That the institutional response was an abuse of power entrenched in white-supremacist values[13] gave multitudes the acumen to witness said abuse and to refuse it. A collectively authored artworker solidarity letter exists now, hosted by Creating New Futures and signed by more than 1,300 people.[14] It says, "Montclair State University's response is an expression of settler colonialism. It is not an outlier. We cannot stand by while it continues."

It is not an outlier.

How do our cells become oriented to justice?

13 "Montclair State University Statement Regarding Emily Johnson," bit.ly/montclair-johnson.
14 "A Statement in Solidarity with Emily Johnson & Our Calls to Action," bit.ly/call-to-action-petition.

Abuse protected, defined, measured toward expansion and profit—against care, community, civil rights, human rights, self-determination, sovereignty, culture, life, and land—is strategy. Cultural, educational, nonprofit institutions in what is called the US are based on these same settler-colonial logics. If, like Montclair State University, these institutions are permitted to continue to exist, to be funded and attended while they remain in these logics, relying on an extractive ethic for their continuance, then they teach and make possible further destruction of Indigenous lands, further extraction from, and harm to, Indigenous, Black, and other communities, minds, and lives.

Sarah Ahmed[15] teaches us how institutions bury complaint, render complaint harmless as they defend what to me is most abhorrent, their "property." The physical space, the campus, the IP, the web domain of the institution, and everything learned, forced, or silenced inside becomes entangled in their version of power. It becomes inescapable, and that replicates harm.

We cannot stand by while it continues.

"As a public land grant university, Montclair State University needs to return public lands to Indigenous peoples through Land Back processes."[16,17]

This is one call to action in the artworker solidarity letter. Their collective calls to action are a powerful and generative path forward, not only for this one specific institution or for the broader performance art field but also for the extensive nonprofit and for-profit extractive industrial complex.

15 Sarah Ahmed, *On Complaint*, The Wheeler Center, 28 October 2018.
16 Robert Lee and Tristan Ahtone, "Land-Grab Universities," *High Country News*, 30 March 2020, bit.ly/land-grab-universities.
17 "Landback Manifesto," landback.org/manifesto.

What if we do insist an ethics of non-extraction? Can this be our solidarity, our reorientation?

Amber Webb,[18] a friend and a fellow Yup'ik artist and activist, honors Missing and Murdered Indigenous Women, Girls, Trans, and Two-Spirit people. She draws their portraits. *Their names rip through me, I breathe beyond the capacity of my lungs*, but I cannot comprehend what Amber's body transforms as she draws the lines and makes the marks. Amber's gestures a calling, a healing imprint, making the shapes of their eyes, their lips, their noses, their faces; her cells as she works in this otherwise overflow, oriented to justice. I imagine a portal space may come into being between portrait revealing self and Amber's hands, a space protected, alive where we are all being future beings. Amber has screenprinted the portraits onto massive qaspeqs, larger than any human could fit. Prayer, function, a tentacular exhumation of our grief, larger than we can hold onto, this grief, big enough to fit entire villages into. This garment, a speculative architecture, too, where our beloved are honored, held, healed, and danced for in that way that conjures joy forward and present. The qaspeqs are an archive of transformation, of community process and conversation. They are law, too. They presided over testimony for HR 10 in 2019,[19] a resolution in support of Savannah's Act, and over testimony for VAWA, the Violence Against Women Act, with specific inclusion for Alaska Native Women, who had been excluded before.

18 Amber Webb, bit.ly/amber-webb-instagram.
19 Alex DeMarban, "Giant Gaspeq Shines Light on Missing and Murdered Indigenous Women," *Anchorage Daily News*, 18 October 2019, bit.ly/mmiw-qaspeq.

Angel Acuña, Nia-Selassi Clark, Linda LaBeija, Denaysha Macklin, Annie Ming-Hao Wang, Angelica Mondol Viaña, Ashley Pierre-Louis, Katrina Reid, Kim Savarino, Sasha Smith, Stacy Lynn Smith, Paul Tsao, Kim Velsey, Sugar Vendil, and Emily Johnson perform on a pink and blue sculpture at night, in Queens, in Lenapehoking.

Nataneh River, who is from the Caddo Nation and the Delaware Nation of Oklahoma, wrote:

to stand against this city
sit against this city
sleep against this city
speak against this city
is to birth life

Under their hands are a world and breath, and all possibility. *I can never speak of the horror until I can, and then I do.* What about the other hand, holding up the first? What about the ongoing messiness of making? The forest is an archive of breath. We said that; Joseph Pierce, Karyn Recollet, and I.[20]

The city of New York is cutting down more than 1,000 mature, healthy trees and bulldozing fifty-seven acres of public parkland in my neighborhood on the Lower East Side of Mannahatta in Lenapehoking, under the guise of a flood protection plan called the East Side Coastal Resiliency (ESCR) project.[21] It is not flood protection, and it is not resilient.[22] It is a waterfront development scheme, a land grab on stolen land.[23] The whole city process: disenfranchising community, falsely enlisting community

20 Emily Johnson, Karyn Recollet, and Joseph M. Pierce, "Kinstillatory Mappings," 2021, catalystdance.com/kinstillatory-mappings.
21 East River Park Action website, eastriverparkaction.org.
22 Dante Furioso, "Trashing the Community-Backed BIG U: East Side Coastal Resilience Moves Forward Despite Local Opposition. Will NYC Miss Another Opportunity to Lead on Climate and Environmental Justice?," *Archinect*, 13 July 2021, bit.ly/ny-coastal-resilience.
23 Michaela Keil, "Land Grab," *Brooklyn Rail*, February 2022, bit.ly/park-land-grab.

input, disregarding a community-backed plan that does not involve bulldozing the park, denying the existence of a value engineering report (claimed by the mayor to be the reason they need to destroy the park), to the release of said report, but redacted, to a lesser-redacted report, to conflicts of interest at multiple stages regarding Department of Design and Construction and HR&A, the real estate firm the city contracts with. I could go on.

The original, community-backed plan for resilience in Lower Manhattan was called "The Big U." The city's plan is more expensive and more destructive. It alienates the community from the park.[24] Kids here won't see shade for sixty to eighty years, when sapling trees planted atop one million tons of fill, once settled, mature; Elders here won't feel shade again. The million tons of fill used to create a levy supported by a concrete wall will send particulate matter into the air in a neighborhood with already high asthma rates and at a time during ongoing pandemic when we know even a slight increase in particulate matter in the air increases the rate of Covid deaths. We have already suffered so much death from Covid here. East River Park is the only available green space for the residents of the Lower East Side, mostly Latinx, Asian, Black, Indigenous, and Elder community members who are mostly low-income too. We play at this park, BBQ, play baseball, kids run around; ceremony and all manner of prayer is held here; runners, bikers make use of the esplanade by the river, where fishers catch perch, bass, and bluefish; birders and foragers roam the wilder parts of the park filled with native species of plants like spiderwort and milkweed that the migrating monarchs depend on, and sessile-flowered trilliums. Lovers make out, or more, on benches and hidden rocks, kids have birthday parties, some people live here.

Thousands of people and thousands more of our more-than-human kin depend on this land. The trees themselves offer more than 260,000 pounds of oxygen to our air, which needs all the help it can get each year. A lesser-known endangered bee lives in one specific area of this

24 Sixth Street Community Center, "Save East River Park," 26 May 2021, bit.ly/save-east-river-park.

park, and last year I watched a rare wild orchid bloom. A red-tailed hawk frequents gatherings. The Lower East Side Ecology Compost Yard is a wildly popular program where 3,500 households a week compost their food waste, preventing hundreds of tons of organic matter from entering landfill, and citywide reduces four billion pounds of airborne carbon per year, the equivalent of 385,000 cars off the roads. The Lower East Side Ecology Center and compost yard are being evicted for ESCR. Dedicated neighbors are fighting this plan,[25] demanding a stop to ESCR, an independent environmental review, interim flood protection, and a plan that does not rely on antiquated concrete walls for flood control or commit ecocide in the name of climate resilience. A different plan that does not destroy East River Park and a thousand trees. We're having a march on April 18 in protection. You can join us.[26]

The first trees cut down were on the south end of the park near an area called Corlears Hook. Lenapeyok launched and landed canoes from this bend, harvesting from and traveling this estuary. It is the site where Dutch settlers, in 1643, massacred more than a hundred Lenape adults and children in a concerted attack on both the east and west sides of the island.[27] Violence returns to itself again AND again and AGAIN, until it is healed. Before the trees were cut, Andrea Haenggi and I wrapped them in a protective offering of care, plastic orange construction fencing, mimicking the fencing around trees that were not to be cut, yet. It is difficult now to find where these first cut down trees existed, squirrel nests and all. The city ground the stumps away. There has never been a landmark or acknowledgment of the massacre at this site. The colonizing city is intent on erasure.[28]

25 instagram.com/1000people1000trees.

26 Lincoln Anderson, "'Save Our Park!' Hundreds of Protesters—No Politicians— March Against East Side Resiliency Plan," *The Village Sun*, 19 April 2021, bit.ly/save-our-park-protest.

27 Joe Whittle, "'Tourists' in Our Own Homeland" HuffPost, 3 July 2022, bit.ly/ tourists-in-homeland.

28 Nathaniel Cummings Lambert, "East Side Coastal Resiliency Project (ESCR), and Corlears Hook Massacre, Lenapehoking Report," 29 November 2021, bit.ly/Lenapehoking-Report.

Years ago, lying on a quilt with a rambunctious child who notices five stars above in the middle of this brightly lit city. The child asks, "Why do they shine, these points?" Pinpoints, like pinpricks, like needle tips, like pointed tufts of matter. Like star moss. It's not a scientific question. It's not a poetic one either. I see them, stars, creating pathways. I see them reach down, and I see us arc up. Are you the star keeper? Are you the fire master? I love, Karyn Recollet said: yes, I am the fire master.

/

Let go. Let go. Let go. Fucken that notion, sometimes. Sometimes it's the holding on that is most bright. This is my land. These are my stars. Not mine, but you know what I mean. Inescapable, what my great-great-great-grandma Kwimaq pulled forth.[29] Incommensurable with your, yes, maybe *your* inability to see. We wear these masks in protection. I wear this mask in survivance. It will all look different one day, this mask and me inside it, traveling worlds.

Jasmin Shorty, Stacy Lynn Smith, Ashley Pierre-Louis, and Sugar Vendil are centering love's forces and wielding justice in consensual acts of change.[30]

You are asked to acknowledge land.

/

29 Emily Johnson, *Inbetween Kwimiak*, *Blue*, commissioned by Onassis Foundation, 2021, bit.ly/Inbetween-Kwimiak-blue.

30 Emily Johnson, *Being Future Being*, catalystdance.com/being-future-being.

From my position here in Manahatta: Save East River Park, Frack Outta Brooklyn, Stand with Shinnecock, multiple neighborhood alliances fighting rezoning in Chinatown, Gowanus, on Governor's Island, in NoHo and SoHo. Further, Stop Line 3, No DAPL, Protect the Arctic, Oak Flats, Bears Ears. Land protection efforts are happening everywhere all the time and moving bit by bit by bit across the ground and waters. They and we are all related.

The Field Museum, on Ojibwe, Odawa, and Potawatomi land, the land of the Council of the Three Fires, holds nearly 2,500 belongings on display and in the stacks of the Northwest Coast and Arctic People's Hall. This list of our ancestors sits in an envelope in my living room. Every one of these ancestors, every one of these belongings needs to be sung to, fed, talked with, prayed for, healed in a different way. I do not know all the ways. I do know they all need to go home.

In 2019, in this hall, I covered the E-word, which is displayed prominently and repeatedly in this hall, with black gaffer's tape.[31] Now, with the director of exhibitions and Debra Yeppa Pappan, the Native community engagement coordinator, I am tending a project of intervention that stems from this action, which is why the records, this heavy archive of taking, are in an envelope in my apartment. It is taking a lot of time to read them and to tend to what is next.

An emphasis on a moment. Rape, and conquer, and taking, and naming, and stolen children, and stolen land, and outlawed language, and stolen masks on walls in exhibits, and medicine removed from its purpose. That's what the E-word makes me think of.

Don't tell me you don't know what decolonization means.

/

31 Emily Johnson, "Care Action at Field Museum," Instagram, 2 October 2019, bit.ly/care-action-field-museum.

So, these are the territories or the places or the directions or the unknowns of this dance. Land. Celestial. Inside. Outward. Underneath.

Stop resourcing racist and extractive cultural institutions with your time, knowledge, money.

Return our belongings.
Give our land back.

/

Emily Johnson, a Yup'ik womxn, is crouched low on one leg; her other leg is reaching beyond the edge of the sculpture and into the air. She is gesturing with her arms, and her hands frame her face. Her head is reaching up, and it seems she is telling a story. Her eyes are closed.

She is wearing a short, bright blue jumpsuit, which has a low-cut V-neck, and brown work boots. Her hair is down and somewhat wet from sweat.

The ground was above her then. All the brightnesses broken through, necessary and insistent.

Q&A

Could you share how you became involved with site-specific choreography? And can you speak more about this connection between the body and the land?

A When I was small, I grew up on Dena'ina land in what is colonially called Alaska. I grew up in a rural area. I have brothers who are twins, and because they're twins, they were always doing their own thing. I played a lot by myself in the woods. There was one day when I wrapped my arms around a tree. It was aspen, I think. I wrapped myself around the tree, pressed up against the tree with my arms all the way around it, and I was looking up at the branches. The tree was swaying in the wind, and I could feel the sway through my body. I could see it and I could feel it, and even then, I could sense the roots below. I was really little, and I remember being so awestruck by the realization that I was dancing with this tree. I think back to that often and I tried to recreate it decades later, but I was forcing the experience too much. I realized that it is not about how I want to dance with the tree. It was really the tree dancing with me back then.

I think about this in relation to this question because I do not believe I do site-specific dance. Yes, places are specific. Places and sites have specific history, and the work is land based. But I am in relation with land in a way that is continual, that is not stopped by any border of the specifics of a place or a site. There is this land dance that I do, where we move down to the ground that is always present. So, even if we are inside, we reach ourselves through the matter of the building to find the ground below and then in a process of being with that ground and recognizing that the ground is spreading

out from all directions. Because the ground is made of bits, and each bit touches the next bit and the next bit. If you had enough patience, if you could breathe underwater, then you could move with the ground, bit by bit, and you could continue and go under the river and up the mountain and over the ocean. So there is this way that dance is part of the time-space travel, being in two places at once. That is the process and technology that I think of and work with, because to me there is a way when I am in a place and when I am in relation with land, I am in relation beyond that specific place, and that is part of this celestial-ness that Karyn Recollet reaches me toward.

How have you moved through the resistance of dance and art to engage with social and political activism? What tools have you learned in this process of healing, vibrating with words? You said, "Violence will continue to be repeated until it's healed." How can this process of healing through the body be acknowledged to its full potential?

Q

A

I think that question is in a way the answer. That is the process that I am continually in, in that vibratory space of transformation. Yes, through breath. Yes, through body. Yes, through resistance. Yes, through survival, and yes, through saying you cannot cut down these thousand trees and destroy this fifty-seven-acre park. No, you cannot lay this pipeline that will haul fracked gas through Brooklyn. The naming and endurance are all related in the process of other worlding. Imagine if non-extraction were our solidarity and work ethic, imagine if our land is back and our belongings are returned. Yes, we make our institutions better. Yes, we build our relationships, but also, yes, we close down the institutions that are not willing to meet this moment.

BORDER FORENSICS

TRACING VIOLENCE WITHIN AND AGAINST THE MEDITERRANEAN FRONTIER'S AESTHETIC REGIME

April 16, 2021
Charles Heller and Lorenzo Pezzani, London, UK

Moderator
Kerry Bystrom, Associate Dean and Professor of English
and Human Rights, Bard College Berlin

Image by Border Forensics

INTRODUCTION

Kerry Bystrom

Charles Heller and Lorenzo Pezzani's work has been inspiring me for quite some years now. Heller is a researcher and filmmaker whose work has a long-standing focus on the politics of migration within and at the borders of Europe. He is currently a research associate at the Centre on Conflict, Development and Peacebuilding at the Graduate Institute in Geneva. Pezzani is a London-based architect and researcher who currently runs the MA program in Forensic Architecture at Goldsmiths, University of London. His work explores the spatial politics, visual cultures, and political ecologies of migration and borders.

In 2011, Heller and Pezzani cofounded Forensic Oceanography, a collaborative project that critically investigates the militarized border regime and the politics of migration in the Mediterranean Sea. It is not an exaggeration to call the methodology developed in the Forensic Oceanography program stunning. As someone from the United States who has been based in Europe now for a decade, I found so much inspiration in the projects that have been completed by Heller and Pezzani toward holding the EU accountable for the severe violence that is taking place on our "borders" in the Mediterranean Sea.

There is something about the vastness of that space that makes it possible to get away with murder. The work that Heller and Pezzani have been patiently and painstakingly doing is clawing back at that. By using art and technology in such an important and compelling way, Heller

and Pezzani have found ways to make visible these vast places that are usually outside the radar. They create evidence that aims to stop this violence from continuing—by, for instance, exposing modes of privatized border security and government-trained and -funded coast guard practices. Their ongoing project of mapping has broadened to include deserts and other large, seemingly unmanageable spaces.

In 2021, Heller and Pezzani founded Border Forensics, a new research and investigation agency which builds on the Forensic Oceanography project they led from 2011 to 2021.

TRACING VIOLENCE WITHIN AND AGAINST THE MEDITERRANEAN FRONTIER'S AESTHETIC REGIME

Border Forensics

Border Aesthetics

The European Union's migration regime imposes a particular "partition of the sensible"; in the terms of Jacques Rancière, "it creates particular conditions of (dis)appearance, (in)audibility, and (in)visibility." As a result of their illegalization, through the EU's policies of exclusion, people who decide to migrate, despite the denial to do so through legal means, are forced to resort to informal infrastructures of mobility, which include transnational networks of migrants who exchange information and services, the smuggling networks they resort to for a portion of their journey, as well as actual means of transport such as overused and overcrowded boats. Migrants are *illegalized*—their illegality is a product of state laws—and therefore they must migrate *clandestinely*, a term with etymological connotations of hiddenness and secrecy. As a result of their illegalization, migrants must seek to cross borders undetected, literally under the radar.

The EU's migration regime imposes a particular "partition of the sensible"—it creates these conditions of invisibility for migrants seeking

to cross the sea. On the other hand, what all security-oriented agencies aiming to control migration try to do is to *shed light* on migration, and in particular on acts of unauthorized border crossing, in order to make the phenomenon of migration more knowable, predictable, and governable. We see this ambivalence captured in the image produced by the Italian border police. Migrants are crossing during the night, while an aircraft, probably of the Italian border police, is using infrared technologies to detect their unauthorized border crossing. To this effect, a vast *dispositif* of control has been deployed at the maritime frontier of the EU, one made of mobile patrol vessels but also of an assemblage of multiple surveillance technologies through which border agents seek to achieve the most complete possible "integrated maritime picture," with the aim of detecting and intercepting migrant vessels. These technologies range from vessel tracking technologies, coastal and ship-borne radars, to optical and synthetic aperture radar imagery. Together, they compose what Karin Knorr Cetina has called a "scopic system," and "an arrangement of hardware, software, and human feeds that together function like a scope: like a mechanism of observation and projection."[1]

However, I think it is crucial to see that, while there is this opposition between migrants to migrate across borders under the radar and the attempt of states to shed light upon their unauthorized border crossings, in fact the partition of the sensible, operating at the EU's maritime borders, is far more ambivalent than this kind of binary would lead us to believe. On the one hand, migrants in distress may do everything they possibly can to be heard and seen when they are at risk of drowning. This way, they are not only seeking to avert the possibility of their imminent death, but also seeking to use the humanitarian logic that has become embedded in the practices of all actors at sea, including those whose very aim is preventing illegalized migration, to forward their own objective of crossing borders.

Conversely, border agents not only attempt to deliberately hide the structural violence inherent in practices of policing maritime migration—thus allowing these practices to perpetuate themselves in full

1 Karin Knorr Cetina, "The Synthetic Situation: Interactionism for a Global World," *Symbolic Interaction* 32, no. 1 (2009): 64.

impunity—they may also choose *not to see* migrants in certain instances. Rescuing them at sea entails the responsibility for disembarking them and processing their asylum claims and/or deporting them. This has led to repeated cases of migrants who have been left abandoned to drift at sea, as in the "Left-to-Die Boat" case.

Borders and their management impose certain aesthetic conditions on migration bordering practices and border violence. It is among others in this aesthetic field that we have sought to intervene through our practice. However, the aesthetic regime operating at the maritime frontier is never fixed; it is contested by migrants, NGOs, and artists. It is transformed by states that may seek not only to conceal but also to spectacularize migrant deaths, using this spectacle to justify their very policies of exclusion.

Over the years, a crucial concept for us to try to navigate this ever-changing and ambivalent aesthetic field has been the concept of the *disobedient gaze*, which we have forged. With this concept, we seek to hint at the imperative of not revealing what states seek to reveal, and instead revealing what they seek to conceal. Once again, this *disobedient gaze* needs to be constantly repositioned in relation to ever shifting aesthetic conditions, operating at the maritime frontier. Borders and their management impose certain aesthetic conditions on migration, bordering practices, and border violence. It is among others in this aesthetic field that we have sought to intervene.

From the Absence of Images to Their Excess

The relation between border violence and border aesthetics is also ever shifting, and demands painstaking attention in the positioning and visual aesthetic strategies that we use in trying to contest that very violence. We would like to probe this question by focusing on a momentous shift that took place in the aesthetic regime of the EU maritime frontier, and that somehow splits our work on this area in two moments: one, before 2015, and the other after.

In our first investigations, which took place before 2015, we had to deal with a radical absence of images. A very good example of that is

our investigation of what came to be knowns as the "Left-to-Die Boat" case, in which seventy-two passengers who had left Libya in the attempt to reach the coasts of Italy were left to drift for fourteen days despite repeated contact with the military ships and helicopters that were present in the area in the frame of a NATO operation and arms embargo against Libya. The reluctance of all actors to rescue the drifting passengers led to the slow death of sixty-three people.

The only photographs of this event to have ever been revealed to the public since 2011, taken by a French surveillance aircraft during the first day of the migrants' journey, have been revealed to the public thanks to an investigation by the Council of Europe. Several other photographs taken during the events have so far remained inaccessible and continue to haunt our investigation ten years after.

In the interviews we conducted with the nine survivors, they describe how at the end of their first day of navigation a military helicopter flew over twice, photographing the migrants waving and crying for help before flying away and fading into the night. After drifting for ten days with almost half the passengers onboard already dead, the boat was again approached by a military warship, but the special forces onboard, in the words of one of the survivors, Dan Haile Gebre, "only took pictures, nothing else." The migrants themselves photographed back, using their mobile phones to document these encounters. While these various photographs would have supplied irrefutable evidence of the crime of non-assistance, they have so far remained out of reach. The images taken by the migrants are likely to have been destroyed upon their imprisonment after drifting back to Libya's shores. While the images captured by the military might still exist somewhere, stored on a flash card or on a computer hard drive, they have so far remained inaccessible to any investigation.

In the absence of incriminating photographs, our investigation into the "Left-to-Die Boat" case attempted to reconstruct a composite image of events by working with the weak signals that underpin truth-production practices, in the field that Thomas Keenan, after Allan Sekula, has called "counter-forensics." In particular, we corroborated testimonies of survivors by mobilizing, against the grain, the vast apparatus of remote sensing devices, which have transformed the contemporary

ocean into a vast and technologically mediated sensorium. For instance, by combining satellite imagery with a drift model that maps the trajectory of the boat after it ran out of fuel, we were able to establish that the bright pixels appearing in the image and circled in red represent large ships located in the vicinity of the migrants' boat after it had run out of fuel. All vessels in the area had been informed of the distress of the passengers on board the migrant boat as well as its position and could have easily rescued them but chose not to intervene. In this way, we repurposed surveillance tools, which are routinely used for the policing of illegalized migration, into evidence of a crime of non-assistance.

Instead of replicating the technological eye of policing, we chose to exercise what we have called a *disobedient gaze*, redirecting the light shed by the surveillance apparatus away from illegalized migration and back toward the act of policing itself and the

violence it structurally produces.

By affirming a right to look, our investigations have challenged the state's monopoly of vision, which has turned the Mediterranean into a space of opacity.

The aesthetic regime at sea, however, changed dramatically after April 2015, when, in the aftermath of the largest shipwreck ever recorded in the Mediterranean, nongovernmental organizations reacted to state authorities' persistent inaction and began conducting search-and-rescue operations in the Mediterranean with their own vessels. The critical presence of NGOs has not only allowed the rescue of thousands of people in distress but has also profoundly enhanced the ability of nongovernmental actors to monitor events at sea. Aware of their critical role as witnesses of human rights violations taking place at sea, NGOs transformed their ships into veritable audiovisual recording apparatuses, installing surveillance cameras on their decks and masts and equipping their crew with GoPro cameras. The sudden flooding of sounds and images produced by civilian groups has allowed us to challenge the accusations that NGOs are colluding with smugglers, as in our investigation from "The Iuventa Case," which provided fundamental evidence of how migrants have been systematically intercepted and violently returned to Libya in violation of international law.[2]

This new aesthetic regime also forced us to rethink how to navigate and intervene within these media-saturated environments. In order to cross-reference and geolocate all elements of evidence, we collaborated with Forensic Architecture and used 3D modeling as an architectural scaffolding that allowed us to recombine the multifarious points of view that make up this composite vision.

2 Mare Clausum, *The Sea Watch vs Libyan Coast Guard Case* (2018), bit.ly/mare-clausum.

What emerges from the painstaking work of synching up and connecting all these different elements of evidence is a form of truth construction that is neither subjective nor objective, but perhaps more collective.

A truth that is certainly more fragile and less heroic than the notion of Truth with a capital "T," which we inherited from the Age of Enlightenment, is nonetheless still powerful as long as it allows to assemble around itself new subjects and collectives. While Forensic Oceanography's first investigations had to deal with a radical absence of images, those that came after grappled with their multiplication. In using and coming to terms with the extended field of image production, we are also confronted with several ethical and political challenges that emerge when dealing with representations of violence against Black and Brown bodies. This became clear to us, particularly in the frame of our work on the *Sea-Watch* case.

Aesthetics of Outsourcing

Criminalization was one of the two main dimensions of the Italian and EU strategy and policies aimed at sealing off the central Mediterranean at all and any cost. The other dimension of this policy was the re-outsourcing of border control to non-European actors and particularly across the central Mediterranean to the Libyan Coast Guard. Outsourcing not only involves the use of third-party non-EU actors, which give these practices of violence a distance that allows Europe to evade responsibility; it also has an aesthetic dimension of making sure that violence is perpetrated out of sight and away from scrutiny by EU civil society.

The aesthetic tools developed by rescue NGOs, which *Sea-Watch* radicalized in 2017, was fundamental to documenting the violence of outsourced border control, leading to the interception of migrants in the central Mediterranean and allowing Libyan coast guards to take them back to Libyan soil, where they are tortured and detained and their lives violated. Using the audiovisual footage generated by these different cameras and audio recording devices, we collaborated with Forensic Architecture to spatialize a particular incident of partly failed interception, in which Libyan coast guards sought to block migrants on a rubber boat. *Sea-Watch* intervened to rescue those already drifting at sea, while some of the passengers captured by the Libyan Coast Guard were able to jump overboard and reach the European rescuers. Thanks to this audiovisual archive and the reconstruction we produced, we were able to document with unprecedented precision the way these violent interceptions operate. This documentation was submitted to the European Court of Human Rights, and a legal process is still ongoing, in which Italy is targeted by proxy.

As important as the audiovisual material produced by *Sea-Watch* has been for our reconstruction, and the ongoing demands for accountability that aim, through litigation, to force Italy and the EU to interrupt their policy of outsourced border control, it has also confronted us with new difficulties and questions that we still ponder. The images produced by *Sea-Watch* bring us to the heart of events in an intimate and disturbing proximity with bodies, their cries of distress, struggling for their lives. We are faced with scenes of radical precarity, images of people drowning, and even death. From the perspective of the continuously recording

camera fixed on *Sea-Watch*'s mast, we see a man's body slowly swallowed by the sea's liquid mass, after the Libyan Coast Guard prevented the *Sea-Watch* crew from rescuing him.

These are horrific images of a horrific event, and their presentation as documents to a court entails that this violence must remain in the brutal form in which it was captured. Even if the survivors we worked with wanted these images to be seen as part of their demand for justice, and even if this footage constitutes essential evidence to incriminate both the Libyan Coast Guard and European states, working with and displaying such imagery conjures a difficult and unresolvable question: How to contest the violence of the EU's outsourced policies of border control without reproducing other forms of symbolic violence in the process?

Our use of these images is haunted by the ghost of the dead from whom we will never be able to request consent to use this footage.

Their lives were made visible to us only "in the moment of their disappearance."[3] While the initial use of these images within our video has been geared to a judicial context, as a consequence of their further circulation in different cultural institutions and political forums, no generic public can be assumed as a viewer of these images.

3 Saidiya Hartman, "Venus in Two Acts," *Small Axe* 12, no. 2 (2008): 12.

Our own work of reconstruction is affected by the inherent ambivalence of the images produced by NGOs as part of their humanitarian interventions. Georges Didi-Huberman, in his critique of Ai WeiWei's 2017 film *Human Flow*, reminds us of Walter Benjamin's outlook on criticism as "a matter of correct distancing."[4] We might then ask if the images captured by NGOs have brought us too close. How can we reintroduce distance from within this extreme proximity? In retrospect, it seems to us that as important as those images are to our human rights investigation, the human rights form and language do not allow us to sufficiently address these questions, which we have explored in our writing and exhibitions. In relation to human rights and the arts, we might question or consider how we might use our artistic perspective to push the boundaries of human rights itself.

How might we further insert into the heart of human rights practice a stronger dimension of reflexivity in relation to image production and circulation, without undermining human rights claims?

4 Georges Didi-Huberman, "From a High Vantage Point," *Esprit*, no. 7–8 (2018): 65–78.

How might we challenge the boundaries between human rights and the arts and affirm our own critical human rights and aesthetic approach as a unitary practice? These are among the questions and tensions that continue to occupy us, and which, as Saidiya Hartman underlines, are "unavoidable in narrating the lives of the subaltern, the dispossessed, and the enslaved."[5]

Militant Evidence

When we show these images and videos, we try to think quite precisely about what it means to take a video that was produced and geared toward a legal context and bring it to an artistic one. Instead of simply revealing or showing the NGO images, we attempt to somehow subtract some of those images from immediate vision. Not because we do not want to show them—we do want them to be seen and we do want people to engage with them at the request of some of the witnesses and survivors. Rather, we seek to create a threshold of reflection, asking viewers to think about and to take a step closer to seeing those images. Another way in which we were thinking about how these questions steer the Border Forensics project is to think further on the ways in which evidence operates in these various contexts, and here we have been particularly inspired by what Ryan Watson calls "militant evidence."[6] He elaborates on this concept in an article that was written in the wake of Rodney King, whose videotaped beating took place thirty years ago, in March 1991, and can be considered the beginning of a new era of citizen *sous-veillance*—where citizens turn their camera lens back on to the state and on to power.

In Ryan Watson's words, "Militant evidence heralds an expansion of documentary media and activism beyond visibility of individual videos, and toward the visibility of systemic structures of violence and racism, and the larger media ecologies that documentary media circulate

5 Saidiya Hartman, "Venus in Two Acts," 12.

6 Ryan Watson, *Radical Documentary and Global Crises: Militant Evidence in the Digital Age* (Bloomington, IN: Indiana University Press, 2021).

within—social media, television, upload and streaming sites, courts, and government and policy arenas, both official and unofficial."[7]

Thinking about "militant evidence" is part of an attempt for Watson to go beyond what has been called "visible evidence," an overreliance on the moment of revelation—believing that just showing something would precipitate a series of consequences, generally toward a kind of more emancipatory situation, which has been proved time and again to very rarely happen. While he does not discard the value of visible evidence, he reflects critically about its limits, especially when dealing with violence on Black and Brown bodies. Watson does that by reflecting on what he calls the "effective and affective" dimensions of evidence. He writes, "The effective form of evidence attests to the fact that something has occurred and can be used in official venues or as part of larger advocacy campaigns. The affective components stem from a desire to generate and accumulate affective evidence and to move others into actions and practices against state violence. In this formulation, the camera captures not only visible evidence but also forces that, when properly harnessed, contextualized, and accumulated, can engender a host of effects and affects within larger media and activist ecologies outside of official venues."[8]

The concept of militant evidence draws its power from two main intertwined affective and effective vectors. The first is the corroboration and accumulation of networked images, witnesses, and testimonials. Second, when accumulated to a great degree, each piece of evidence builds on the power of others, whereby accumulation helps to reveal the long-standing and systemic effects of police violence and a host of other structural issues. This concept tries to think about the combined effect within the court and outside the court, within parliamentary debates and outside official forums. While our practice has sought to forge different voices and modes of operation when intervening in different forums, here we would like to think about how we could suspend and further trouble this boundary. How can our reflection on image production inflect our human rights practice, and conversely, how can

7 Watson, *Radical Documentary*.
8 Ibid.

our work of strategic litigation allow us to think through some of these aesthetic questions?

To contest the violence of borders, one also needs to contest aesthetic boundaries. In doing so, we need to be aware that the aesthetic regime within which we intervene is ever shifting and is a highly ambivalent field.

At times, we enter highly ambivalent practices of revealing in order to contest border violence, but these revelations can also lead to other forms of symbolic violence at the same time. This is a challenging aesthetic field that we need to constantly navigate, and which demands careful positioning.

We have been leading the Forensic Oceanography project for the last ten years, and we are in the process of initiating a new project, a shift from Forensic Oceanography to a broader Border Forensics. Tom Keenan was very important in supporting and helping us steer our Forensic Oceanography project, thinking of the ways we might bring some of the tools that were then being forged within the broader Forensic Architecture project and how we might bring them to bear on violence

at and through the sea. While Forensic Oceanography is focused on the EU's maritime frontiers and mostly the Mediterranean, Border Forensics expands to other border zones such as the Sahara and the Alps, and to other modalities of border violence that may occur far away from the border itself—for example, within the very fabric of European cities. After ten years of work, our effort has been joined by other NGOs and activists. There is a far greater capacity to document violations at sea to support migrants than when we first started our project. This capacity is not at all developed in other border zones, and that is one of the reasons we see the necessity to expand our activities today. So it is a process of expansion but also of consolidation and of reorientation. This is also a time in which we reflect on our practice over the last ten years, assessing what we have been able to achieve, but also consider the limits and ambivalences of our practice, and to steer our project in the directions we would like to explore for the next ten years. Border violence is enduring and we know will be perpetuated for as long as the conditions that produce and reproduce mobility conflicts remain. Inequality and racialization are themselves perpetuated, and we certainly see that our work will be necessary for the foreseeable future.

Q&A

Q

The discussion of an aesthetic regime raises for me an aporia between the necessity to reveal evidence and the value of representing it in a manner mediated by aesthetic intervention. I wonder if in some sense the mediating screen somehow blunts the visceral impact of, for instance, the body cam and bystander footage that has been so successful in mobilizing dissent against regimes of power. Would there be a direct correlation there between, for instance, the Floyd/ Chauvin video and the video from the water, which you were having some hesitations or reflections on? What do you think about that?

A

I would say two things: First, there have been different moments of circulation of images captured by *Sea-Watch*. They released a raw cut of the footage recording this incident only days after it occurred. So that rawness, if you will, was maybe more present in that form and in the moment of circulation of these images. I think in our reconstruction with Forensic Architecture, it becomes somehow more analytical—we are using these images and spatializing them to respond to different questions, such as what we need to respond to accusations against *Sea-Watch*.

The claim by the Libyan Coast Guard was that *Sea-Watch*, by its intervention, was endangering the migrants, and there is a dimension of humanitarian dilemma in that intervention, in the sense that, when they are approaching to rescue people, some of the passengers, to escape the certainty of being violated in Libya, prefer taking the risk of drowning while

trying to reach *Sea-Watch*. By spatializing the image and looking at it analytically, we were able to show that there were many people in the water at the time *Sea-Watch* arrived. These people were entirely left unattended by the Libyan Coast Guard, who were only interested in intercepting the boat and capturing its passengers. I think the role of our reconstruction is to use these images in a slightly different way. Although the passage in which we see a person drowning is left in that raw form, it has another duration. We give it another temporality. We try to maneuver through using these images analytically and conveying their rawness when it seems to us necessary.

Q

It seems that one of the conditions of returning the "disobedient gaze" involves rights groups becoming equipped with the same surveillance tools deployed by the state and military. There is an implication of having to compensate for the power asymmetry first, before one can begin to seek justice, especially in an incident at the scale of the Left-to-Die Boat.

A

It is a great point, and obviously there is no easy way out of the contradiction that is exposed here. There was a moment when the campaign of criminalization of NGOs started in late 2016. One of the very first tools that was used to criminalize them was a video that was published by a Dutch think tank connected to the far right. The NGOs used the best of tracking technologies, which we have been using a lot in our own work to track the position of commercial and military vessels and try to hold them accountable. The same tools were being used to track the NGO ships. They edited this video where you can see very fast-paced ships going

back and forth between the coast of Libya and Sicily. The narrative that was going on there with their voice-over and text was to say these people are creating an invasion and facilitating the invasion of Europe by these migrants. Obviously, it was very scary for us to see a tool that we have been using a lot and quite effectively to contest the violence of border control being totally reinvented. That is something that we try to reflect on and think about.

I think it would be wrong to think that there is an original or pure state in which technical means are devoid of any intention and can be used in a correct way. It is rather a kind of constant tension and struggle of appropriation and reappropriation. It is also one that I think is quite important in doing away with the idea of this uncorrupted use of new media and technology. Rather, it is an invitation to start from the middle and as part of that we hope to continue showing and thinking about how to position ourselves within that context, in a way that generates progressive aims and fights for migrant rights.

ASHMINA RANJIT

POLITICS
OF BEING

April 23, 2021
Ashmina Ranjit, Kathmandu, Nepal

Moderator
Danielle Riou, Associate Director,
Human Rights Project, Bard College

Photo by Chu Feng-yi

INTRODUCTION

Danielle Riou

It is my distinct pleasure to introduce multidisciplinary artist Ashmina Ranjit, who is joining us from her home this evening in Kathmandu. Ranjit's career as an artist and feminist activist spans over two decades, utilizing a range of media, including video, live performance, sound work, and printmaking. Her performances and installations have addressed the politics and culture of patriarchy, class, and caste in Nepal, as well as dealing with the country's ten-year insurgency and civil war, which ended in 2006. Ranjit's work has had a profound and lasting impact, not only on contemporary art discourses in Nepal but also on the broader societal discussions about women's rights. She is one of twenty-two artists featured in the Jakarta Biennale in November 2021, for which she is working with artists and art spaces in both Jakarta and Nepal in a collaborative art project on the theme of islands. Her work will also be featured in the Kathmandu Triennial, slated for October 2021, of course "pandemic willing" in both instances.

In addition to her artistic practice, Ranjit is well known for having founded two important contemporary art spaces in Kathmandu in the late 2000s, in response to the need for physical places that can accommodate research-based, conceptual art making that goes beyond simply aesthetics. LASANAA is an art space for conversations, workshops, and residency programs with national and international artists that nurtures conceptual art discussions and practice in Nepal. The second art space,

NexUs, has a gallery for exhibitions, talks, readings, a healing workshop, and an organic farmers market. Though NexUs had to shutter its doors during the pandemic, and the future of the space is uncertain, we hope that it can be reanimated at a future time.

Ranjit is currently developing an artistic fellowship program in collaboration with Samata Foundation and with support from the Ford Foundation, titled Engendering New Narratives for Just Futures: Nepali Dalit Women and the Covid Pandemic. This program will bring together twenty young Madhesi Dalit women artists to develop their practice, highlighting key themes that they feel should be brought to a public audience and doing so through a medium of their choosing. As Ranjit put it, "It's always the upper upper caste writing about the lower caste here, so this project is an attempt to address and subvert this cultural and epistemological dynamic through the development of this group's artistic practices." At the core of her work are feminist critiques of cultural measures of value, bodies, voices, labor, and artworks, which make her interventions so critically important to Nepal's nascent and evolving democracy.

POLITICS OF BEING

Ashmina Ranjit

The fact that I am here with you all, sharing my experience, understanding, and observations, without reservation, is already political.

In this talk, I will be discussing key aspects of my work as they have evolved over time in my own political becoming as an artist. The first is my coming into political consciousness through art by focusing on women's experiences, body, and sexuality. The second is engaging with a decade-long brutal civil war, from 1996 to 2006, when Maoists demanded a different kind of state in Nepal. Third is "collaborative artivism," my most recent political and artistic development as an *artivist*, whose art and being is always about collaboration with the other.

Political Consciousness through Art

When I was born, disappointment spread in my family. A girl instead of a boy. Soon after, my parents separated and left me with my maternal grandmother, who breastfed me and took care of me. When I was around six years old, out of the blue, my father came and picked me up, cutting off every relation with all my maternal relatives.

As a child, I was always fascinated by the free-floating clouds. I kept looking at the clouds, but after I was brought to my father's home, the nanny who looked after me warned, "Stop looking at the clouds. Women

are not free like the clouds. Thinking about clouds will only make you sad." My male cousins constantly reminded me *(chhoriko janma hareko karma)* that being born a girl is to be "defeated by karma." But I refused to accept these proverbs. I kept watching the clouds, hoping and searching for ways to be free. For years I wanted to be a pilot, because that would take me into the open sky and the clouds that mesmerized me. Later, looking back at my daydreams, I realized that my desire to fly was a metaphor for my intense drive to actualize my selfhood, to be who I am, and to become who I want to be.

In my father's home, I was to become a Nepali citizen in a Hindu patriarchal nation-state. I began school, where I learned that my father and the nation-state were the most important and had power, while my maternal grandmother, who had raised me in her own local language, no longer meant anything.

My father is a well-known painter in Nepal. He paints landscapes of the country, its cultural practices and people. He always wanted his son, my brother, to follow in his path. He never imagined that I would become an artist like him. When I started painting landscapes and other things, my father was proud and taught me the skills of a painter. When I became an art student, training in painting and sculpture, I began to develop my political stance in reaction to the self-censorship that pervaded the art school ethos.

I began to take the experience of women as my main subject. I asked myself what it meant to be me, rather than just somebody's

daughter or sister, within Nepal's Hindu patriarchal establishment.

I examined the prohibitions, suppressions, and exclusions experienced by women in every stratum. I chose to share my views freely, and for this I was regularly rebuked by my senior mentors: "Ashmina talks about nothing but gender. Ashmina talks about nothing but politics!" They said, "Art is not about these things. Art transcends gender, transcends politics." I would reply, "How can that be possible? I have a womb, you don't. My experience of my body and what I experience through my body is different from yours. I can't conform to your vision of what my art should express." My father also rejected this kind of conceptual, political, and feminist art.

It soon became clear to me that this art fraternity saw their work mainly as the production of objects and aesthetic commodities that served the nation. They were reluctant to focus on any political themes that went against the Panchayat ideology. At that time, Nepal was governed by a single party, the Panchayat system, and under the control of a monarchy. Any citizen could be jailed for expression of dissent, and art schools trained students to make images that supported that system. Most of the artwork in the thirty years (1960–1990) of the Panchayat system was in support of ideas of a highly stratified and unequal society, based on a deeply rooted caste system, where one language, Nepali, one religion, Hinduism, and one manner of dress dominated a rich diversity of ideas and people. Less than 15 percent of Nepal, mostly men from Brahmin and Chhetri caste groups, controlled all aspects of everyday life and high politics in Nepal. Art reflected that political system with images of mountains, beautiful people, and temples that glorified ideas of the Nepali nation.

In the mid-1990s, I left Nepal and went to Australia to study art on a fellowship from the Australian government. I received praise for my work exhibited outside of Nepal, and audiences always asked if other

Nepalese artists made contemporary work, and if I was Nepal's only woman contemporary artist. I accepted the affirmation as an individual but also felt humiliated that outside of the country, almost nothing was known about Nepali art or artists. I realized that we needed to build an artist community of like-minded practitioners, create mutual support, cohesion, and solidarity.

In my earlier works, I framed the female body as the locus of gender discourse, identity, patriarchy, and sociocultural values. These themes later became particularly relevant in the discourse of democracy and gender equality. When I exhibited works about gender and sexuality in Kathmandu, to my knowledge no woman had publicly talked about sexuality before. Some Nepalis reacted by saying, "Oh, you lived abroad, that's why you are doing such work, you better go back [to Australia], this is not appropriate for Nepal. You are unmarried, how do you know anything about sexuality?" My father, too, rejected me, and I left home.

Soon after, I brought the exhibition to Tasmania and received mixed responses that applauded the show for its boldness or reduced it to generalized Asian culture or tradition. In one instance, an ABC radio host interviewed me and asked how I was able to make such daring work. Quickly answering her own question with, "Maybe because you are from the Indian continent where the *Kama Sutra* was written. It must be easy for you."

I was an outsider in both places.

My work in Nepal was thought to be influenced by experiences abroad, while in Australia it was thought to come from my apparent understanding of a particular South Asian literature and religion. This gave me a new perspective and way of engaging with gender and patriarchy, not only in relation to Nepal or South Asia, but as self-referential expressions of gender, sexuality, and politics that explore global meanings.

Challenging Hindu patriarchy, social norms, and stereotypes that

denigrate women are recurrent themes in my works. I often use specific markers of Hindu auspiciousness and sexuality, such as hair or the color red as metaphors for the feminine experience. In *Shakti Sworoop: A Taboo Subject* (2002), red no longer refers to the auspicious color of the woman as goddess or of her married state. Rather, red refers to the flow of the menstrual blood that is at once seen as unclean and dangerous, a latent and forbidden symbol of women's sexuality, desire, and procreative powers. Throughout South Asia, menstruating women are considered polluted and are not allowed to cook or perform rituals. In some places, they even need to reside outside the house for four days. These subversive subjects and provocative displays are aimed toward a viewing experience that is meant to evoke a distinct sense of unease and a shocking reaction to the subtexts of this represented body.

It is only through discomfort, I believe, that we can begin to engage the implicit messages that surround us.

By working with these personal issues in a public arena, I invite dialogue and controversy. In *Feminine Force* (2009), I explore patriarchal mores of menstruation and menstrual blood as polluting. I constructed a dress made of 10,725 individual pieces of sanitary pads, signifying the number of pads a woman uses throughout her reproductive cycle.

Within the Brahmanical patriarchal worldview, there is a long-practiced structural violence within traditions that claim that only sons carry the genes of the father and daughters do not. Hence, sons inherit the family property and citizenship is handed down from father to son. The vicious circle of power is enshrined in the constitution itself, which

makes women second-class citizens or stateless subjects. For women, becoming a citizen has been an ongoing battle in Nepal. If one does not have citizenship, one cannot own property, and vice versa.

To address these issues and start conversations that might influence policymakers, I initiated the *Land Project* in 2009. I invited several artists, policymakers, and the general public to participate in discussions, workshops, and interactive art performances. In the first part of my performance, I hung myself on an excavator, struggling to stand firm in the void. The question raised was, Where do I stand? If there is no place to stand on my own, where do I stand?

In the interactive part of the performance, I wore a white jumpsuit to represent the earth. I walked around asking people whether they have property and how they would pass it on. I invited the land commissioner, other experts, and artists to draw their property on my body. This started a conversation with policymakers and activists in the hope that we would influence inheritance law. By law, women now have a right to inherit familial property, but it is rarely put into practice. My father and brother hold on to the belief that only men should inherit land from their family.

Because of such ideas about land inheritance, citizenship also goes through one's father. Gaining citizenship through one's mother is a long-fought and ultimately defeated battle for Nepali women. The latest constitution states that women can confer citizenship to their children only if they are married to a Nepali man. If your mother is Nepali and your father is a foreigner, living in Nepal, you will be stateless. The constitution both controls women's sexuality and determines how women can pass on citizenship to their children, based exclusively on their relation to a Nepali man. I started a protest-performance about this issue during a women's conference in 2015, where I carried on my back a skeleton I named *Bipad*. *Bipad* symbolized the dead state and male family member. I carried him for a year and even at Bard College when I visited in 2016. At that time, earthquakes had devastated Nepal as the government ratified the constitution that prevented women from passing down citizenship on their own.

Insurgency / People's War (1996–2006)

"To enact the impossible dream of a few, is it necessary to give nightmares to many? To maintain the pride of a few, is it necessary to play with the lives of many? Now, when the past heroes, singing songs of freedom and right, have turned into jesters, who will save us other than ourselves?"

—Artist statement enacted during the Maoist insurgency / People's War in 2004

During the conflict, the Nepali artist community in the capital was cut off from the ongoing war, and many artists believed art should not be

associated with politics. As the insurgency reached its height, people were turned into statistics as they were killed and abducted by the army or the Maoist rebels. An emergency state was declared, and uncertainty and helplessness consumed most people.

We were impatiently asking ourselves: What does it mean to be a citizen of this country at this time in history? How can we intervene? How do we respond to and resist this war?

Along with other creative intellectual friends in civil society, thinkers, poets, writers, artists, theater performers, and musicians, we kept our spirits alive by pulling together a daylong interdisciplinary art event titled "Bichalit Bartaman" (2002) at Basantapur Durbar Square, in which hundreds of people participated. This event was technically illegal because of the ban on public gatherings of more than four people; we could have been jailed for breaking the law. Instead, public participation at this gathering surpassed our expectations, and the event became a ray of hope. If we come together as a collective force, we can raise our voice for peace and democracy, to live as dignified citizens without fear.

During the civil war period, when the Maoist insurgency was at its peak, I undertook performances on a large scale. In November 2003, I did another performance at the Nepal Academy of Fine Arts, using

painful sounds of crying mingled with sound clips from radio broadcasts of the casualties of war, which came out of hidden speakers. People heard these sounds while they walked around a burning map of Nepal and through bushes and grass, experiencing something like an ambush in a war zone. This piece allowed us to emotionally reflect on the ongoing war and to question politics, and many visitors to the piece suggested that I bring the work to a larger public and in an open space. It was one of the first art events to be covered on the front page of the national newspaper. I think this was because each group claimed it as expressing their own struggle, from the Maoists to the Nepali government and the public at large.

In 2004, I created another ambitious and large-scale performance titled *Happening*, which involved an hour-long slow walk from the clock tower, which is located in the heart of Kathmandu, to the Singh Durbar, at the center of the government where the majority of ministries and the parliament building are located. That day we engaged over ten thousand people who stood alongside the road, at first out of curiosity but soon to become part of the performance. Despite the state of emergency in Nepal, the performance was not stopped, and opposition parties, leaders, politicians, students, government officials, civilians, police, army, and the general public all became active participants. I collaborated with fifty-two radio stations nationwide that agreed to simultaneously broadcast the same sounds I used in the Nepal academy piece in an hour-long radio program throughout the country. While the radio stations across the country played the sounds of women wailing in grief and terror, I led the procession from the clock tower to the parliament building. At our request, residents participated in *Happening* by turning their radios on full volume during the procession. Over a hundred performers, young artists dressed in black, joined me. To assist with the performance, locals placed buckets of water on the road for my team to mix in the color red. As part of the performance, the performers were splashed with red-tinged water while falling on the road as if shot dead. Their fallen bodies were traced over with white chalk, referencing the human casualties of this civil war. At the same time, hundreds of thousands of people throughout Nepal participated, because they heard the crying and sorrow on all the radio stations.

I was warned by my loved ones, my friends, and many intellectuals about the danger of doing such performances. However, living with uncertainty and witnessing the increasing helplessness of people was harder than doing nothing. The unexpected way people, especially ordinary Nepali citizens, responded to and became part of the nationwide *Happening* was one of the most profound experiences I have had. In those days, people in power used fear as a weapon, especially against the weak and vulnerable. The public performance brought together armed forces, Maoists, the general public, and students, all against violence and in support of peace and democracy.

Happening was about the power of our collective voices, a common commentary in favor of peace and against ongoing violence.

Through the process, the art became part of a larger political activism that effectively engaged the public as engaged performers whose voices could no longer be ignored.

In 2004, through a Fulbright Scholarship, I went to Columbia University in New York for my MFA. There, I engaged in performances that involved both Americans and Nepalis where we talked about Nepal, the ongoing conflict, and how we could support and be involved from the diaspora. *Tamas: The Darkness* (2005) examined the present national scenario, suspended between hope and despair, light and darkness, *jyoti* and *tamas*. The performance raised important questions about some of our famed national values and characteristics, such as honesty,

trustworthiness, and simplicity. It allowed us to ask troubling questions concerning the status of a subject and a citizen in a modern nation state.

In February 2005, at the height of the armed conflict, King Gyanendra seized full power to end the civil war, shutting down communication, disbanding the government, and taking over sole authority. I was still in New York and physically dislocated from the country and the new communication shutdown, which left people in the diaspora to experience a dark void in the name of supposed democracy. The feeling of desperation, suffocation, isolation, and the sense of helplessness and despair towered over me. I needed to connect and express these emotions and actions in the name of this democracy. How do I bring forth the essence of this experience and backward movement?

In response to these events, *Tamas: The Darkness* used projection of image, sound, and performance. I deployed the cow as a metaphor for complacent citizens in the post-democracy moment, using a fourth-grade textbook description of the cow, "a docile, shackled animal that serves but never demands. The cow is also recognized as a symbol of the fecundity of the goddess, and the docile nature of a cow is celebrated as the ideal Hindu female behavior." The performance and video begin in darkness, with the harsh sounds of chains dragging on the floor alluding to the sense of intense oppression of the current regime. There is a sense of discomfort and dislocation, with the sounds emerging from the darkness as I read lines from the text, which culminate in the following verse: "The cow is so important in Nepal. The law says someone killing a cow could get a life sentence. In this way, cows are treated as Nepali subjects. They are simple, docile, and useful. Cows become a powerful metaphor for both gender and citizen."

Collaborative Artivism

I mentioned earlier that right from the start I was told that art should not be political. My colleagues looked at things from an exclusively aesthetic perspective and were not interested in creating counternarratives or questioning the status quo. Their goal was to create the kind of art demanded by elite patrons and to sell these works. I confronted them

about what appeared to me to be a lack of political consciousness and a refusal to take risks. I received much backlash from the apolitical art fraternity, yet, in 1999, upon my return from Australia, I actively began working to form a practitioner collective.

By the mid-2000s, contemporary art in Nepal was no longer confined to painting on canvas and had started to take different forms with different media. Artists were experimenting, but the exploration was mostly aesthetic and not conceptual, social, or political. In order to connect art to the larger national context and to the goal of sociopolitical transformation, I introduced the term *artivist* within the art movement in Nepal, and through workshops, collective strategies, and modalities, I brought creative people together. It was an initially challenging task. I had to convince many people that this was the way to create and reinforce an art community, which will always be more significant than any one individual.

LASANAA began as a conceptual space in 2007 to establish activism within the arts movement in Nepal together with a group of creative thinkers, academics, social scientists, activists, and journalists. Our goal was to promote contemporary Nepali art, to develop conceptual art discourse in Nepal through critical thinking, and ultimately to bring about social, cultural, and political change through our art+activism, i.e., *artivism.*

Through LASANAA we introduced something new to the Nepali art scene. Before this, the field was dominated by long-established traditional art practices and a certain kind of late-twentieth-century modernism. Art primarily reflected the artist's personal approaches to religion and culture, and sociopolitical themes were rarely discussed or represented. As an alternative art space that systematically involves the community in dialogue, idea exchange, and artmaking processes, we challenged the elitism of established art and curatorial practices. Along with supporting contemporary practitioners, we continue to build local discourses of art history, theory, and criticism through different research-based and participatory programs. Our projects are very diverse and provide an opportunity for national and international artists to explore art forms beyond the conventional and traditional. After the peace process, a constitutional assembly was about to form, and at LASANAA we wanted to make sure women's participation and gender issues were addressed,

securing equal rights in the upcoming constitution. We began the project *Different Voices* (2007) in a move to transform the established concept of billboards as spaces for advertisements, often depicting demeaning and discriminating commercial messages. The *Different Voices* billboard proposed using that space as a medium to promote gender-sensitive messages through thought-provoking artworks.

Our philosophy at LASANAA underpins the functioning of NexUs Culture Nepal, which is a creative space in central Kathmandu that we use for our *artivism* purposes. It is a place for artists and the community to gather, have discussions, collaborate, and innovate. Our building includes a café, rooms for artist residency, fellowships for Nepali artists, a gallery, an event terrace, and a garden. Our cultural work includes talks on art and books, sale of artworks, and an organic farmers market. NexUs provides a space for artists from different genres, social scientists, musicians, and authors to mingle. At NexUs, we also organize workshops, performances, and a biweekly open-mic night, all of which uphold an inclusive ethos. Our long-term goals include running creative art camps for disadvantaged children, expanding the artist residency program to an artist village and studio spaces, and creating and facilitating an online alternative learning institute. We want to develop into a self-sustaining cultural resource, but we do struggle financially. NexUs is run by volunteers, with a handful of paid staff. Worrying about how to pay the rent often keeps me awake at night, and due to Covid we had to close NexUs for the time being.

If we look at the current Nepali art scene, most of the young contemporary artists have been part of LASANAA's various projects and are representing their work within Nepal and abroad. The exhibition "Nepal Art Now" (2019), at the Welt Museum in Vienna, is a good example, providing a view of the diverse range of contemporary art practices happening in Nepal. The art movement in Nepal has now gone in many directions, including that of *artivism*, and there is a lot of diversity. People draw on diverse sources for inspiration and use all kinds of media to depict themes and subjects that are remapping traditional iconographies into contemporary grids.

Q&A

I am curious whether there are any influential womxn art-
ists and activists, especially from the South Asian region,
whose practices informed your work when you were a
young artist.

Q

A When I was growing up, I did not have access to fem-
inism as a theoretical concept. The theory came later
in my life, but my surroundings, experiences, and the
separation between male and female was something
that really pushed me. My family and the surroundings
I grew up in seeded these ideas long before I realized
them. At the same time, when I was growing up,
beginning an art practice with some of the activists
and intellectual friends, we talked about these critical
issues. Indian feminist activists whom I encountered
at a few workshops were very inspiring, such as Kamla
Bhasin. In my early days, I was influenced at our school
by Shashikala Tiwari, whose work is very feminine
without claiming it as political. There are not only one or
two, there are many people standing up for themselves
and being who they are.

You have strongly portrayed women's menstruation, which remains taboo in Nepalese society. Can you share examples on the impacts that your artivism has created? For instance, young urban girls have started not to follow certain traditional norms. How do you see that evolving? Q

A It is always hard to get the numbers. The impact is beyond the statistics, but I see the bigger impact. When I started talking about these issues, people around me had not yet begun discussing blood and menstruation—it was still a taboo subject. Now it is openly being talked about and there are so many discourses and conversations going on. Young girls started rejecting the traditional way of living and the *chhaupadi* tradition that forced girls and women to reside outside their home for four days during their menstrual period. This practice was recently made illegal.

I would not claim it is only because of my artwork. There are parallel movements and conversations that have been ongoing for over twenty years to bring this issue forward. Also, for the younger generation, talking about the body, the experiences of the body, and how they carry their body has changed. If you look at our older generation, most of the time, women's bodies are like a screen because of the laws that promote shame, and so one's body is not seen with pride, but instead, because you have breasts, people look at your body differently. Now, I see the conversation has shifted and become more open here. These issues will not fade away immediately; they are practices that go back hundreds of years and are deeply rooted in people's way of thinking. It will take time to change, but it is changing.

MARK SEALY

PHOTOGRAPHY, RACE, RIGHTS, AND REPRESENTATION

April 30, 2021
Mark Sealy, London, UK

Moderator
Marcelo Brodsky, photographer,
visual artist, and human rights activist

Photo by Steve Pyke

INTRODUCTION

Marcelo Brodsky

It is an honor to be sharing this webinar with you about art and human rights. I am very confident in the relationship between art and human rights. And that art can help us understand what human rights mean, and how the younger generations need art to understand the meaning of human rights and to help them think about the field further.

It is in this intersection of art and human rights that I first met Mark Sealy twenty-five years ago in Mexico at a Latin American photography conference organized by Pedro Meyer. We have been friends ever since and have worked together in many different circumstances, so it is a pleasure for me to introduce him.

Mark is an activist, curator, writer, and photographer. Thirty years ago, he created Autograph, the agency of Black photographers in the UK. He is the author of a book called *Decolonizing the Camera: Photography in Racial Time*, which he will talk to us about. We will learn about the trajectory of his work and the curatorial practices that led him to think about how to decolonize our vision, the lens, and the camera. His work asks if it is possible to transform Images from colonial times into something different.

Autograph is located in a very nice building in East London's Rivington Place, and has an exhibition space and a public program. Mark has led it for thirty years and has a full staff that he kept on board for the whole period of the pandemic. The work and energy that has gone into keeping

the space and all of the employees on board is something that attests to Sealy's commitment and relationship with human rights and activism.

I am very interested in hearing what he has to show and say about his whole program, in which I have had the privilege of taking part. Though Autograph started as an agency for Black photographers, it evolved and expanded into focusing on human rights at large, and including non-Black artists such as myself from other parts of the world.

In Latin America, we have long struggled for human rights throughout the region, and we have been able to share our narratives with Mark and with Autograph. I thank Mark for opening up his vision and for his focus on human rights on a global scale.

PHOTOGRAPHY, RACE, RIGHTS, AND REPRESENTATION

Mark Sealy

My work examines how Western photographic practice has been used as a tool for creating Eurocentric and violent visual regimes. It uses the central principle of "decolonizing the camera," a process by which an analysis of photography takes place within and against the political and violent reality of Western imperialism. Through this process, it explores issues of race and cultural erasure within photographic history through the direct analysis of photographic works, informed by two underlying questions. Firstly, has photography been a liberating device or an oppressive weapon that holds the viewer/producer and citizen/subject in a violent system of continual exposure? And secondly, what epistemic value has photography brought to our understanding of difference?

My curatorial research considers whether photographic works concerning visualizations of the "Other" can produce different or new meanings when they are critically read through the prism of colonialism, its inherent forms of human negation, its temporalities, and its violence. This is done by locating and reading the photographs within the ideologies of colonial time, space, and place. My curatorial work functions as a critical dialogue with colonial and imperial photographic histories and the social and visual spaces they occupy. Through the work I do

in photographs, I argue that within these common types of racialized photographic spaces, we can analyze the varying levels of violence done in photography, concerning the making of the Other, and from that perspective, consider how these forms of violence worked in the service of Western colonial and imperial powers.

"Colonialism has been a dispossession of space, a deprivation of identity,"[1] and it created a system of image production that maintained and disseminated its dehumanizing ideologies. At the center of my work lies the proposition that it is necessary to recognize photography as an active agent of Western colonizing authority at work on the body of the Other, both in the past and in the present. It is only through this that we can begin to fully recognize the complexities and political impact of photographs in visualizations of racialized subjects.

Throughout my work I suggest that a photograph of a racialized subject must be both located and then de-located from the racial and political time of its making, and not solely articulated by its descriptive (journalistic) or aesthetic (artistic) concerns. I maintain that it is only within the political and cultural location of a photograph that we can discover the coloniality at work within it, and only then, through understanding this, can a process of inquiry begin into the nature of its colonial cultural coding. A key aspect of my thinking is to not allow photography's colonial past and its cultural legacies in the present to lie unchallenged and unagitated, or to be simply left as the given norm within the history of the medium.

DECOLONIZING THE PHOTOGRAPHIC IMAGE IS AN ACT OF

1 Barlet Olivier and Chris Turner, *African Cinemas: Decolonizing the Gaze* (London: Zed Books, 2000), 39.

UNBURDENING IT FROM THE ASSUMED, NOR- MATIVE, HEGEMONIC, COLONIAL CONDITIONS PRESENT, CONSCIOUSLY OR UNCONSCIOUSLY, IN THE MOMENT OF ITS ORIGINAL MAKING AND IN ITS READINGS AND DISPLAYS.

This is therefore a process of locating the primary conditions of a racial-ized photograph's coloniality, and, as such, my practice works within a form of Black cultural politics to destabilize the conditions, receptions, and processes of Othering a subject within the history of photography.

The notion of destabilizing photography's historical past works through the lens of Stuart Hall's critical writing on race and representation, especially concerning the British Black subject's construction within photo-graphy, which he wrote of in the 1980s. Of relevance are his essays titled "Reconstruction Work: Images of Post-War Black Settlement," from 1984, and "New Ethnicities," from 1988. In "New Ethnicities," Hall theorizes a decisive turn against the Eurocentric stable and negative representations of the Black subject within Western visual culture. He also articulates a politics in which the "unspoken and invisible" subjects in post–World War

Il Britain have challenged spaces of representation and marks the moment that Black subjects begin to contest their historically fixed image. Building on the notion of the "unspoken and invisible" Black subject within Western culture, and analyzing a series of complex photographic episodes drawn from various archives of Western photography, I make the case that such archives, in their myriad representative ways, are loaded with unspoken and culturally invisible subjects, and that the photographs within them work politically and aggressively as active agents locked within a colonial photographic paradigm. Hall claimed that the 1980s was a "critical decade" for Black British photography. I assert here that the 1990s should also be read as a transformative period that heralded the arrival of the Other as photographer within mainstream Western cultural institutions. Throughout my work, I consider the political and cultural conditions of both these decades as decisive periods in which the Black subject entered both the domain of representation and its international art markets.

The work I attempt to do is to examine the visual and structural complexities at work within a given photograph's social and political formation, which I refer to as its "racial time." Racial time enables us to consider a photograph's function as a sign within the historical conditions concerning the "relations of representation" that Hall discussed in "New Ethnicities." I employ the idea of racial time to signify a different but essential colonial temporality at work within a photograph. In "New Ethnicities," Hall also presented the notion of the "end of the essential black subject." If this is the case, then it marks an important conjuncture in history and photography where the Other is brought into focus. Hall therefore shifts the cultural landscape in the understanding of the Black subject within Western visual culture. I inquire within the work and try to present how the cultural landscape in the making of race has been historically constituted and how that landscape might be read, today and in the future, to produce new meanings. Hall's influence is relevant once more through his essays "Reconstruction Work: Images of Post-War Black Settlement" and "Vanley Burke and the 'Desire for Blackness,'" which I commissioned in the early 1990s. The latter, about the Birmingham-based photographer, is employed as a reminder of the rarity of visual moments concerning *black intimacy and tenderness* within the history of photography.

My inquiries are not limited to the context of British Black cultural politics in the 1980s referred to by Hall, but also extend back through the histories of the medium, so that we can begin a process of understanding race at work in photography. If, as Hall suggests, the end of the essential Black subject was a political reality by the 1980s, then something must have passed on or died. Further, if this is the case, then that ending affords us the opportunity to do new forensic work on the historical sites and bodies of photography that concern its essentializing and racializing nature.

My work aims to locate, excavate, extract, and expose the slippery, ghostlike nature of the colonial in photography, to make the essence of the colonial legacy within photography and its dark epistemes more evident and more visible. I am also the first to admit that this is not always possible.

The images I have worked with in presenting exhibitions have been based in extensive research of key photographic archives, such as those at Anti-Slavery International, the Bodleian Library, the Black Star Archives at Ryerson University, Getty Images, Magnum Photos, and the Imperial War Museum. Analyzing this primary material reveals how Western regimes of scopic violence can be understood in the context of the racialized body, human rights, and photographic history. I am also concerned with the concept of cultural erasure against the Other, and this work is informed by a range of inquiries into history, photography, and racial and cultural politics through the works of Paul Gordon Lauren, Emmanuel Levinas, Frantz Fanon, Michel Foucault, Sven Lindqvist, Paul Gilroy, bell hooks, Claudia Rankine, Judith Butler, Hannah Arendt, Gayatri Chakravorty Spivak, and Stuart Hall.

Levinas invites us to look into the face of the Other as a duty of obligation and as a sign of our infinite and fundamental responsibility for the individual human Other. For Levinas, taking responsibility for the Other is the ethical site where we locate our own humanity and morality. Using Levinas's philosophy of ethical responsibility, I argue that photography, made through the prism of the colonial gaze, has created such a wholly dehumanizing legacy of images of the colonized subject that it may be impossible to rectify.

Fanon's thoughts on decolonizing the mind of the colonized subject here map onto decolonizing photography and relate to the internalizing psychological damage that can occur to the human subject when constantly exposed to dehumanizing representations of blackness. Fanon's view of colonial violence suggests that violence generated by the oppressor is rejected with an equal force, and with this in mind, analyzing photographs of the Black subject from the perspective of a decolonizing critic works as a process of political rejection of Eurocentric photographic practices. This opens such photographs to different possible readings that unlock them from the fixity of the time of their making, which enables us to read, for example, Wayne Miller's photographs as a form of Black performativity to white colonial privilege, rather than simply as empathetic documentary work.

Power, for Foucault, is a function of *panopticism*, in which the threat of permanent visibility causes subjects to become self-regulating and

"docile." In the dynamics of race and violence against the Black body, such power is derived from controlling the Black body through the assumed cultural authority of white rights to observe and display blackness.

In Sven Linqvist's 1992 book *Exterminate All the Brutes*, he examines "[t]he history of genocide as a travelogue through colonial time ... This works as a reminder of the role technology has played in Europe's domination and formation of its colonies." By presenting the tragic consequences of those technological developments for colonized subjects, he reminds us of the importance of revisiting and decoding the narratives of history that sanitize the colonial conquests.

The legacies of colonialism and racism worry the history of photography. They enable the fractures of enlightenment and humanitarian thought to haunt the present.

Photography, when read within the context of European imperialism, has the capacity to function as a morbid reminder of the intense level of cultural violence that was aimed at the Other over centuries. Photographs need to be discussed not just as historical documents but as images open to different interpretations of key moments in Europe's history, such as King Leopold II's violent regime in the Congo or the complexity of agendas

surrounding race at the end of WWII. This form of analysis allows us to read the nuances and gauge the power of the cultural and political forces at work within the history of the genre and to assess how these forces have affected photographic constructions of race, the politics of human rights, identity formations, national narratives, and cultural memory.

Throughout my work, I analyze photographs and photographic practices in which issues of race, human rights, and identity politics are paramount. The priority here is to analyze the extent to which the humanitarian ideals that have often animated the discourse and practice of photography have impacted the historical conditions of race, and to examine whether those ideals have supported or hindered human understandings of race within photography, assessing how photography's dominant regimes have assisted, maintained, and made possible the creation of a racialized world. The historical work on constructions of race and human and civil rights has, through the ongoing institutional hegemony of European photography, failed to alter the colonial consciousness within Western thought concerning theories and cultural attitudes toward race. I have attempted to explore this directly through the images circulated by the Congo Reform Association, which was a powerful humanitarian organization working at the beginning of the twentieth century on religious, political, and humanitarian fronts, and particularly through images made during the post-WWII periods that feature the colonized or Black American subject.

I maintain that photography is dominated by the legacy of a colonial consciousness repressed in the present. If this is the case, then this ongoing imperial mindset means that the colonial visual regimes, historically active within photography, remain inherently intact as the making of photography, its translations, its distribution networks, and its knowledge formations continue to be critically dislocated from the perspective of the subaltern and the marginalized. Realigning photography to include a reading from subaltern or "different" perspectives,[2] following Levinas, I argue that we must engage in forms of decolonization work concerning the Other, and consider the history of photography from within a politics

2 Stuart Hall and Mark Sealy, *Different: A Historical Context* (London: Phaidon, 2001).

of representation. In this, the primary objective is revealing the specific or latent political implications of a given photograph's production, especially its reading and its reception when the face of the racial Other is brought into focus.

The photographs by Alice Seeley Harris and the work of the Congo Reform Association are important images. They are an acute reminder of the complex layers of the horrific violence that was directed at the African body in the Congo at the turn of the twentieth century. Across Europe and the United States, Seeley Harris's early humanitarian photographs highlighted the outrageous abuse and killings that were taking place throughout King Leopold II of Belgium's Congo Free State. They constitute some of the most politically charged images of colonial violence taken in the twentieth century, and their display in public still has the capacity to inform, educate, and appall, as was evident in the exhibition "When Harmony Went to Hell"—Congo Dialogues: Alice Seeley Harris and Sammy Baloji, which I curated for Autograph ABP at the Rivington Place galleries in early 2014.

Visitors to the exhibition overwhelmingly expressed limited or no knowledge of the levels of violence suffered by the Congolese people. Fewer still understood the role that Seeley Harris and her photographs played in the downfall of Leopold's regime. Like all photographs, however, they carry a multiplicity of meanings according to the cultural perspective from which they are read. Seeley Harris's photographs now afford us the opportunity to inquire why they were, until recently, absent from the dominant narratives of photography's history. They enable us to address why Seeley Harris, an innovative missionary photographer, has been pushed into the background of the history of photography. These photographs, taken in Africa at the turn of the century, are critical to understanding the politics of the European presence on the continent. They also performed dramatic work as documents employed in Britain, promoting political and humanitarian reform in Africa. They were originally displayed as theatrical lantern slides, which functioned within a specific set of scripted performative narratives, working to service and expand the objectives of British Protestant missionaries based in the heart of the Belgian Catholic Congo. Locating them back within this context deepens their significance, enabling us to consider missionaries with cameras as

people uniquely situated on the front line of the British empire, fueling with their "knowledge" the wider enterprise of British colonialism. On the surface, these ostensibly benign photographs "humanize" the African subject by exposing Leopold II's regime of violence. But they can also be read as rallying calls, not for the liberation and freedom of African subjects, but for the construction of a higher, morally colonizing authority that was uniquely British and therefore just.

Seeley Harris's work and the photographs employed by the Congo Reform Association provoke questions of colonial disavowal and disingenuous imperial agendas. Catholic and Protestant missionaries fought for pole position in the race to convert the "natives," a battle that mirrored the wider European conflicts across Africa for territorial gain and control. Through an analysis of the way these images were used by Seeley Harris and her colleagues, I make the case that essentially the Congolese were left with three choices: be converted to Christianity, become slaves, or be killed. None of which guaranteed their human recognition or advanced the case of humanity for the African subject in the West. The camera in the Congo may well have highlighted the plight of the Congolese under the control of Leopold II, but it also contributed to the increased security and certainty of the British Protestant missionary presence. Photographs displayed by the Congo Reform Association were evidently a factor in the elderly Leopold II being pressured to sell his stake in the Congo to Belgium in 1908, just one year before his death, but the king's deluded sense of benevolence lived on through the agency of the Belgian state for at least another fifty years. The racist, dehumanizing, violent ideology of Belgium's rule remained intact for decades, up to and beyond the country's independence in 1960.

While Seeley Harris's work was produced almost half a century before the outbreak of WWII, it raises questions that continue to haunt the postwar moment. Lindqvist's *Exterminate All the Brutes* reminds us that "Europe's destruction of the 'inferior races' of four continents prepared the ground for Hitler's destruction of six million Jews in Europe."[3] The

3 Sven Lindqvist, *Exterminate All the Brutes: One Man's Odyssey into the Heart of Darkness and the Origins of European Genocide*, trans. Joan Tate (New York: New Press, 2007/1997).

deliberate refusal to see those regarded as Other as human subjects in their own right defines a violent literary and visual legacy that is now firmly part of the Eurocentric construction of the making of world history. Through photography, this legacy has marked those whose lives and cultures have value and those whose do not.

The photographs taken at the Nazi death camps have had a profound effect on the consciousness of the modern world. They now count among the most iconic images of human inhumanity to other humans ever recorded or shown in public. Many of them first appeared in *Life* magazine on May 7, 1945, and have been discussed at length by historians of both human rights and photography. However, the specific detail and complexities of the photograph's cultural work is easily overlooked due to the grotesque nature of what it depicts. Nuanced cultural work can slip by unnoticed due to the way in which the photographs have been encoded for public presentation within larger circuits of communication. If we accept the emergence of these photographs, published in *Life* and other Western news media in May 1945, as the origins of "irrefutable evidence" concerning acts of mass extermination of the Jewish people by the Nazis, then it is also important to read them within a wider racial context. They also act as irrefutable evidence of the Allied forces' disavowal concerning the plight of the Jews, the Roma, the disabled, the mentally ill, and the many others who died in the death camps. Photographs and testimonies were available long before Allied soldiers liberated the camps, but this visual foreknowledge gets left out of the grand narratives concerning violence against the Other. The lack of recognition of different indigenous cultures through managed misrepresentations of their alterity in the West is a defining marker of the colonial and postcolonial eras

Eras that, in various guises, continually scrutinized the "dark races" and

dismissed their capacity to rule themselves and, by extension, to fully engage with the politics of their own lives.

By the end of WWII, Europe's and the USA's preferred political agenda was simply to maintain the old cultural-racial status quo. Analysis of racially charged photographs produced in the West during and after WWII demonstrates that this agenda was also played out in the realm of photographic representation. Freedom for the colonial subject, despite contributing heavily to Europe's liberation, was not going to be forthcoming. Western attitudes to race in the late 1940s were resoundingly retrogressive, as was confirmed by the implementation of the Apartheid regime in South Africa in 1948 and the inert responses to it by the newly formed United Nations.

Among the images I have examined are those taken by the celebrated British photographer John Deakin at the fifth Pan-African Congress in Manchester in October 1945, which appeared on November 10 that year in *Picture Post* magazine. Used in an editorial context, they allow us to take the pulse of British journalistic attitudes toward colonial subjects immediately after WWII, and they represent the only in-depth visual account of this significant moment within British colonial politics.

Deakin's photographs accompany an article that focuses on miscegenation rather than African liberation, recalling nineteenth-century European obsessions with racial purity.[4] The *Picture Post* editorial "Africa Speaks in Manchester" unashamedly advocates "white

4 Lindqvist, *Exterminate All the Brutes*.

hostility" toward Black subjects if the demands of decolonization carry any meaningful threat. What begins to surface is the arrogant cultural assumption that the status quo, concerning the empire and its subjects, would be maintained violently as a European right. Within this small body of photographs, their captions, and the text, we can see the early signs of a preferred national story, which locates the boundaries of global freedom in late 1945 territorially, politically, and racially. Analyzing the article reveals a subtle set of wider communications aimed at the British public that, when deconstructed through the prism of race, sends a distinct message that given the end of WWII, there is no further need to embrace or tolerate the colonial Black soldier or worker as a colleague in arms, equal in the fight against fascism. The article works as a reminder that six months after the end of the war in Europe, Africans could "speak" regarding their desire for freedoms, but only according to the terms of the old empire agendas. The article critically inaugurates a process of cultural amnesia relating to the political promises and new images concerning colonial contributions to the war effort, which had been put into mass production and circulation. It also ignores the global significance of the transatlantic agreements that had been signed among the Allied forces that effectively promised freedom for all the world's peoples.

George Padmore, the Trinidadian Pan-Africanist, is quoted in the *Picture Post* article as summing up the mood of the delegates in Manchester, when he says, "A negro's skin is his passport to an oppression as violent as that of Nazi Germany's oppression of the Jews. ... [W]e don't need yellow armbands in Africa, we just need black skins." As far as racial politics was concerned across the pages of *Picture Post* in November 1945, the Black colonized subject was petrified in colonial time. The images, however, belie the new face of radical African liberation and highlight just how out of step the British were with the political mood and determination of their African subjects, many of whom had been hardened by their experiences of war in Europe.

A young German photojournalist, Robert Lebeck, was in the Congo on June 29, 1960, the eve of independence for the newly formed state of the Republic of Congo. On that day, he took what has now become an iconic photograph of African independence struggles. The image shows the ceremonial sword of the Belgian King Baudouin being stolen and held aloft

by an African spectator of the ceremonies. As the "thief" turns to run away with the sword, Lebeck, fortuitously placed, takes advantage of the scene, taking a photograph that helps to establish his reputation as one of the leading photojournalists of his day. Examining the images that were taken before and after the sword was stolen reveals the intensity of colonial rule through the imperial signs of Belgium's symbolic order, thus directing a reading of Lebeck's work away from the traditions within photography that desire the location of a Barthesian-like "punctive" moment within a given photograph. I argue that the images are visually saturated to a claustrophobic degree with the signs of Belgium's colonialism. Reading Belgium's monuments and other colonial tropes that appear in the photographs as signs of historical violence, colonial grandeur, and indulgence offers an analysis of Lebeck's series, not as a filter that works toward the making of a single decisive moment, but as images that act today as turbulent reminders of the past, and visual precursors to the violence that befell the Congo just a few months after its independence. When read now, from the perspective of the known political realities of the Congo, the photographs are important not just as moments that capture African independence but also as a record of the degrees of colonial oppression that were still present at the time of the formation of the new state. The sword thief may well have grabbed the symbol of power from the Belgians briefly, but the white Belgian military presence, which was managing the path to independence, rapidly restored the colonial order. Lebeck's photographs from June 29, 1960, have become a unique register against which we can begin to deconstruct the damaging totalizing effects of Belgium's colonial rule on the minds of both the Congolese and the Belgians.

One of the first post-WWII documentary photography projects that was funded and produced with the specific objective of changing white perceptions of the Black American was undertaken by Wayne Miller. As a WWII photographer, working in the South Pacific for the US navy, Miller was sickened by the devastation he had witnessed. His experience of being on a racially divided ship and what he saw at Hiroshima affected his perspectives on race and humanity so much that on his return home to Chicago, he decided that the most pressing contribution he could make was to try to bridge the cultural and political fault lines that racially divided American society.

Miller's ambition was to bring Black Americans closer to the hearts and minds of white society by presenting a new vision of Black humanity. His project was not a self-financed endeavor; it was funded by two Guggenheim awards. The funding enabled him to work among Chicago's Black community for three years. Miller's photographs taken from 1946 to 1948 represented what was then an unprecedented view of the lives of Black Americans taken by a white photographer. Since their publication in 2000, these images have been celebrated as powerful examples of documentary photographs employed as a vehicle for building empathy between different people. However, given the intensity and history of racism in Chicago in the mid- to late 1940s, it is pertinent to consider Miller's privileged status as a well-financed white photographer photographing Black Americans, and to examine the possibilities and forms of cultural reciprocation between him and his subjects in such a racially tense environment. Cultural commentators on Miller's work have tended to ignore the fact that the images were made within a dominant regime of representation. The fact of Blackness that Miller attempted to make visible was constituted solely from a white perspective in which Miller positioned himself as the interpreter of a form of Black humanity, classically aestheticized within the photographic documentary tradition. Miller does not provide any wider social context against which to gauge the levels of white oppression under which these people lived. Therefore, to read the value of the work, one must literally look outside the frame to see what was going on, politically and culturally, in Chicago, at that time.

Inquiring into Miller's humanitarian project reveals that the photographs became virtually invisible for decades. Instead of being agents for social change in the 1940s US, they became a closed personal archive. They did not surface collectively as images in any meaningful cultural-curatorial context for at least another fifty years, apart from some minor usage by the American Black press to support arguments relating to Black progress in the late 1940s and early 1950s. Two photographs were included as part of Edward Steichen's exhibition The Family of Man, one of which portrays a Black man involved with a sex worker, and the other a depressed-looking Black man dressed in his denim work clothes, sitting on the edge of a double bed where a Black woman lies

fully clothed with her back to the camera, contemplating the condition of a finger nail.

Miller's photographs, from the time of their making against the historical background of racial politics in the Midwest and through the period of their emergence in the public domain, highlight the fact that they were never released into a place where they could perform the work they were funded to do. Both Miller and the Guggenheim allowed the project to effectively disappear for over half a century. The core purpose of the making of these photographs became politically redundant, or at least a failed photographic humanitarian exercise, regardless of how aesthetically successful the images are deemed to be. By not being brought into the public domain at the time of their making, the project was discharged of its original social intent, and its meanings became culturally relocated into an archival story of discovery, rather than photographs read through the work they may have performed in their own time.

The emergence of Black British and African photographers throughout the late 1980s and 1990s is part of the story of Autograph, which understands that work produced in Britain by Black photographers acts as counterimages to the negative ways in which the racialized body had been positioned within the mainstream cultural institutions and the media. Part of the work at Autograph focuses on the practices of the first wave of Black British documentary photographers as well as supporting a younger generation of British photographers whose production has moved away from the documentary tradition, to create scenes where "new ethnicities" can be imagined. I continue to explore the constructions and receptions of African photography in the West and try to assess how African photographers and their works have been placed culturally and critically, or abstracted from their original context, to fit within Western frames of reference.

There is no conclusion, in many ways. The place I would like to pause on is: Within these critical new domains of representation, progress is made toward a less-Eurocentric photographic discourse. However, the process of control and commerce echoes the historically exploitative, competitive, colonizing encounters of extraction and consumption of the image of the Other, how it is managed, and how it is made real in the West.

Q&A

Q *This is an incredibly sustained account of, and assault on, the colonial history of photography. You said that the dehumanizing legacy, or effects of those practices, may be impossible to rectify. And at the same time, you show us these images and perform readings and counter-readings. You made a very eloquent plea for what you called "nuanced cultural analysis." I am interested in the capacity to read and to generate counter-readings of this history and the shadow of the history impossible to rectify. What if it is impossible to rectify? Can you elaborate on what is happening here?*

A Do you know what comes to mind? Toni Morrison's *Beloved*. There's a ghost there, a disastrous moment kind of implicated in it. We've done something to try and save ourselves, but it will always be there. The question is recognizing it, seeing its presence, allowing it to be alive in the room and not ignoring it. Then thinking about what we can do differently in the future. So, it might not be possible to rectify it, it will always be present. To see that presence is a wonderful reminder of what we were, how we had to act, or the things we had to do to survive in those spaces. I think it's a kind of haunting, because photography will always haunt how we are in the future.

The archives are loaded with these deeply disturbing spaces, and we should bring them out, let's have these nuanced conversations. For me, the beautiful images that Wayne Miller produced of a Black man sitting on the beach with his son bring me to tears every time, because I know outside the frame of that photograph, if you veered too far to the left or too far to the

right of that beach, you were crossing into violent terri-
tory. In 1919, on that shoreline, a young Black boy was
killed by someone throwing a rock. The boy happen-
ed to drift into the white part of the beach and it hit him
on the head and killed him. I look at the Black body,
the black back of the man who is quite strong, looking
across and not enjoying the view but being hyper-
vigilant. This is what I mean by the kind of nuanced
view. For some people, it might seem like a nice photo-
graph of a father and son on the beach in Chicago—a
beautiful humanitarian moment of exchange. Rather,
look outside the frame and consider all that other
knowledge about the memory of that space. Also
appreciating the dynamic that the image sits in, what I
would say is its *cosmology*, means that we can begin
to pull out different meanings. Its topologies, if you
like. I want that to be important, to always think about
the wider political context that exists within.

And so, in our time, we will not reset but rework,
rearticulate, position, play. It may not be rectifiable but it
will be different, because the meanings that are gener-
ated, the new knowledge that comes out of that means
that we will be able to read this time differently, and
we will be able to dislocate the stereotypical coloniz-
ing attitudes that are inherent within the making of
photography.

It is about scholarship and bringing different
voices to allow new research to happen. The image
references must be read differently, and if you can
understand how that reading is done or think about
the different themes of which that work is formulated,
then we are in an exciting dynamic time. Let's look at
the work the work is doing, let's allow different work-
ers into the work that the work is doing, and produce
different ways to read these things that are in our lives.
From different cultural perspectives, whether we are

queer, straight, Latino, Catholic, Black, or working class—let's get those multiplicity of voices into the story and level the playing field of knowledge. That is what I have tried to do with the Autograph project, make it a dynamic new portal where people can walk through and think about things differently.

HAMED SINNO

QUEERNESS IN/AS METAPHOR

May 7, 2021
Hamed Sinno, Philadelphia, USA

Moderator
Ziad Abu Rish, Director, MA Program in Human Rights
and the Arts; Associate Professor of Human Rights and
Middle Eastern Studies, Bard College

Photo by HoJun Yu

INTRODUCTION

Ziad Abu Rish

Hamed Sinno is a musician, poet, vocal instructor, and social justice advocate. They have been the writer and frontperson of Mashrou' Leila, a Lebanese indie pop band that started in 2008. The band has had a tremendous impact in the field of music, lyrics, and freedom of expression not just in Lebanon but across the Middle East and North Africa. Individually and collectively, Mashrou' Leila have been an important force for change, entertainment, and joy.

The band toured extensively around the world, collaborating with other artists, human rights institutions, music venues, and museums. The band was started by students from the American University of Beirut as a side project that ended up engulfing their lives and the lives of millions of listeners and followers. Their songs are performed in a Beiruti accent, rarely heard in pop culture. They transcend music genres, defy mainstream aesthetics, and challenge what is considered normative and acceptable in Arabic-speaking youth culture.

Sinno writes and lectures about the convergence of music and social justice and teaches singing from their New York studio. They are currently pursuing an MA in digital music at Dartmouth College.

We are fortunate to be in conversation with them today, after the band stopped performing and many of its members moved out of Beirut. Sinno will share with us the meticulous thought and emotional processes that go into their lyrics. Those same lyrics were used by Lebanese state

officials and religious and conservative figures to demonize and criminal-
ize the band and its members, accusing them of blasphemy and moral
corruption—consequently banning their appearances in the country, a
step that other regional governments also took against the band.

QUEERNESS IN/AS METAPHOR

Hamed Sinno

Acknowledgments

I would like to start by expressing my deepest gratitude for all of you being here, having me here, and holding space for me among you. Because we cannot be in physical communion and the pandemic has taken away our ability to breathe the same air, I would like to start by just breathing together. Taking two or three deep breaths at the same time to sync up our life forces.

I would like to acknowledge that I am an uninvited guest and settler, who works and lives on violated, stolen, and colonized land once stewarded by the Lenne Lenapi people for generations, and that they are its rightful caretakers and protectors. This land has been, and continues to be, occupied by force. As I currently reside in Pennsylvania, I am complicit with legitimizing a land demarcation founded on the fraudulent land swindling perpetuated by the Walking Treaty of 1737. I am deeply grateful for being here, and humbly ask the Lenne Lenapi people for their future mercy and undeserved compassion when we are held accountable for our presence on this land.

As an MA candidate at Dartmouth College, I am also occupying unceded Abenaki land and working within an institution that was founded on exploiting the labor and financial resources of Samson Occom from the Mohegan tribe, who invested time and money into the institution

when it was promised that the college would be dedicated to educating the native tribes of North America. This promise was violated when the college built on Abenaki land in direct opposition to Samson Occom's wishes, and then again when, by the turn of the nineteenth century, the college had graduated only a handful of Native Americans.

We are all building on legacies of unacknowledged Black labor and genius, which has always been visible despite white history's attempts to conceal it, and yet it has never been adequately recognized or remunerated, and has instead been co-opted and appropriated by both the industry and the academy. Furthermore, the freedoms that I enjoy as a queer and genderqueer immigrant are freedoms that were not just given to us but were fought for with blood and sweat by Black, Brown, trans, cis, women, queer, and disabled civil rights activists whose legacies continue to protect our safety to this day.

Music has saved my life, and this land became my sanctuary when conditions in Lebanon became too difficult for me. As such, I am deeply indebted to all these communities. I offer what I have learned about visibility in the hope that it may be of service to your own causes, as I have borne witness in my little time here to the ways in which the colonial project weaponizes visibility, or lack thereof, to further its hold over the land and its people. These acknowledgements are very small gestures that pale in comparison with informed action. I encourage everyone to visit any or all links and find ways in which you can donate, engage with, and support these communities.[1] These are all institutions and organizations that have been vetted by Charity Navigator and scored remarkably well on their rating system. They are, to the best of my knowledge, extremely reliable.

Finally, I would also like to acknowledge that when I speak of my experiences in Lebanon and other parts of Southwest Asia and North Africa, I speak for myself. I am weary, even in these spaces, of speaking

1 The Native American Heritage Association: naha-inc.org/donate; The American Indian College Fund: collegefund.org/ourwork; First Nations Development Institute: firstnations.org/fndi_donate; National Network to End Domestic Violence: nnedv.org/donate-now; Trans Lifeline: translifeline.org/donate; National Bail Fund Network: communityjusticeexchange.org/donate; and Feminist Women's Health Center: feministcenter.org.

to my relationship to homophobia and gender policing, as I am hyper-cognizant that as a recent immigrant to the United States my experiences with bigotry can be, and often will be, weaponized against me and against people like me. This white-supremacist project cherry-picks narratives of trauma and repackages them to justify a homo-nationalist exploitation that minimizes the cruelty and injustice of American imperial violence in the SWANA region, under the pretense of defending the same human rights it actively belittles at home in the US. I am also weary of the white centrality that goes into the auto-censoring impulse to withhold those narratives, and its complicity with heterosexist, racist, ableist, patriarchal, capitalist violence both here and there. I have made my peace with my decision not to silence myself for anyone, to accept the entanglements that emerge, and to proceed and recalibrate accordingly. In other words, I reserve the right to correct myself.

Queerness in/as Metaphor

The intention for this talk is to discuss questions of representation, and there are parts of that discussion that are more straightforward. Like, what does it mean to have someone assume a set of identitarian permutations in the public eye and insist on having their work read in relation to that embodiment? For now, I would like to start with metaphor, which has been a very generative paradigm through which I have been able to understand things about my voice and embodiment that I was unable to articulate before.

I realize that there is a distinction between simile and metaphor in literary analysis, and I realize there is an equally sharp distinction between metaphor and metonymy, which gets particularly salient in the bridge between linguistics and psychoanalysis, where metaphor parallels condensation and metonymy parallels displacement.[2] But for the purpose of this talk,

2 Jacques Lacan, *Ecrits* (London: Routledge, 1997).

I am looking at metonymy, metaphor, and simile as the three heads of Cerberus,

at least as they all operate through disrupting the stability of a word's meaning by creating a conceptual contiguity between that meaning and another idea altogether. In some ways, metonymic displacement is part of why metaphor is successful and metaphorical condensation is part of why metonymy is successful. When thinking of Jose Muñoz's offering of queerness as "a desire for another way of being in both the world and time, a desire that resists mandates to accept that which is not enough,"[3] metaphor becomes ripe with political potential as queerness's linguistic analogue.

Through the correlative function, metaphor displaces the boundaries of significance, collapsing meaning onto other meaning.

3 José E. Muñoz, *Cruising Utopia: The Then and There of Queer Futurity* (New York: NYU Press, 2009).

When "her spirit is a hammer," the hammer moves closer to the spiritual, and the spirit moves closer to forceful collision, and in that space, where language refracts through a six-lettered signifier into the next, is queerness. Metaphor is at heart a dialectic. A negotiation between submission to the binary to yield meaning and dismantling it to surpass meaning. On one hand it submits, because the signifier can produce meaning only in what Ferdinand de Saussure calls a "system of differences,"[4] which is at core binary: The letter H is the letter H because it is not the letter S, or any of the other letters. On the other hand, it dismantles the binary by insisting on life in the in-between: the hammer is a hammer because it is not a spirit, and yet the hammer is also a spirit. It is a *Muñozesque* disidentification with straight meaning, simultaneously existing within and without it. This dialectic betrays the arbitrary caprice that separates the ineffable, the in-between, the horizon from the sky-scraping construction of language. Instead, metaphor focuses on the view of that horizon from the window of the 114th floor and takes a sledgehammer to the wall around that window to maximize access.

In language, as in sexuality, as in gender, a hammer is a hammer is a spirit, and thus metaphor is queerness spoken. It is from this understanding of queerness in and as metaphor that I have attempted to understand the space I have made for myself between words.

Metaphor's queer ability to articulate the in-between is no better elucidated than by its regulation. In my career as a writer and performer in the public eye, I have repeatedly had to contend with a particular trope of metalanguage. Namely, certain thoughts may not be approximated, and their signifiers may not be queered. Metaphor becomes regulated to insist on the omnipotence of straight meaning. To illustrate this further, I would first like to start with a song released by Mashrou' Leila in 2015. The track was composed by the band, and the lyrics were penned by me, which will be the case for all the tracks that I will be discussing.

The track "Djin" was part of an album, *Ibn El Leil* (2015), that we wrote in the wake of my father's death and coincided with the apotheosis of my drinking career. The album wove mythology with politics, mourning, and

4 Ferdinand Saussure, *Course in General Linguistics*, eds. Charles Bally and Albert Sechehaye, trans. Wade Baskin (New York: McGraw-Hill, 1966).

the dance club as something of a time capsule from a very challenging period. The song itself is about the ritual of waking up feeling hungover just to hit the bars again and do it all over again, every day. It felt like dying every morning just to wake up again at night. The extended metaphor was simple and innocuous: "Drinking away grief is trying to be reborn." While there is nothing explicitly queer about the lyrical content, save for perhaps the campy reference in the chorus to an old pop song considered "lowbrow," there is something exceptionally queer about the way it was received. At the time, I was reading Joseph Campbell, and there was something about the whole idea of the monomyth that excited me. The fact that certain narrative tropes emerged across different cultures at different points in history felt like a beautiful testament to the possibility of certain shared ontologies about the human condition, or at least it made it possible to fantasize about people finding common ground through their mythologies.

Naturally, when thinking about dying and returning, the two narratives that came to mind were that of Jesus, who dies at the cross and then rises, and Dionysus, who similarly dies and returns. The more research I did into Dionysian mythology, the more the parallels became remarkable. Both are "god," and the "sons of god." Both turn water to wine. Both die and return. The lyric is structured in two parts: The first verse makes direct references to bacchanalia and Dionysian imagery, and the second half leans on baptism as a metaphor for rebirth. Regardless, the song became an easy way for the band to fall victim to various slander campaigns launched by the right across different parts of the region. Death threats poured in for years. Though there was nothing about the track that took any stabs at faith, the idea of a self-identified queer body using religious imagery in metaphor proved to be enough to cement the belief that the band was intentionally attacking the Christian faith because of a Satanist agenda. The message was clear: you cannot make your own associations to certain signifiers through metaphor if the power structures under which they operate are politically invested in maintaining their meanings, singularities, and your exclusion from their communities.

On the same album is the song "Kalam" (2015). I had just seen a presentation by Dr. Maya Mikdashi from Rutgers University about *sextarianism*, a term that describes the intersection of sex and religious

sect, and the ways in which the Lebanese confessional system interacts with gender, sexuality, and sect to articulate its statecraft and nationalist imaginaries. One example of sextarianism and how it works is the way in which Lebanese women are not allowed to pass citizenship on to their spouses. This is often justified socially by people worrying that extending the right to naturalize would lead to the naturalization of the Palestinian communities living in Lebanon, tipping the scales of the confessional census of the country's population, which is allegedly the way sectarian distribution of parliamentary seats is decided on. Lebanese men can naturalize Palestinian woman, so it is not even trying to hide its double standard. Another example in Lebanon is the absence of a shared civil law when it comes to marriage and divorce, because each sect in Lebanon has a different set of laws that inform how a divorce plays out in the courts. Mikdashi's research opened my eyes to the ways in which patriarchy and nationalism are so deeply intertwined.

At the same time, I was reading Alain de Botton's *Thinking About Sex*, in which he suggested that in a hypothetical scenario where two people meet at a bar and end up going home together to hook up, sex actually "starts" with the conversation at the bar. There was something liberating about this idea that you could divorce sex from its heteronormative definition as it relates to the corporeal, and instead move it toward the conversational and the communicative.

"Kalam" is the love child of those two thoughts. The song charts an interaction between two people that begins with someone asking the other person to dance and ends in climax. The central conceit of the song is to try to speak to someone without gendering them. Arabic makes the question of gender pronouns interesting because the language extends gender to everything—affecting the conjugation of verbs and the inflection of nouns, not just pronouns. I often find myself diving into Reddit forums where people discuss language, and some have made the argument that because gender is so pervasive in the Arabic language, it could suggest that the language has a very different conception of gender altogether, or at least that gender in the Arabic language is different, means something different, even within the same community. These conversations often devolve into the same tired tropes of people accusing each other of complicity with imperialism for trying to carve

spaces for themselves within the culture by looking for gender-neutral pronouns. As such,

"Kalam" intentionally switches genders with every other line, for both the speaker and the person they are speaking to. This operates through submitting to the binary and then insisting on life in the in-between.

Finally, the song does something with the voice that is relevant to the scope of this conversation. The vocals on the track are tethered to language for most of the track. It is not until after the breakdown and buildup in the bridge that the voice comes back in climax, but this time it escapes language altogether and instead just leans on "ooh" vocalizations in the falsetto register. When language finally returns after that bridge, it remains disembodied, and the voice using language is processed through a vocoder. The voice becomes tethered to the in-between, and the erotic becomes the path to that space that evades language, even if just gesturally by way of metaphor.

The idea of articulating life outside the gender binary by employing both of its polarities simultaneously has always been interesting for me.

Ghassan Ali Moussawi writes brilliantly about the nature of compulsory heterosexuality in Lebanon. While drawing on the work of Michael Kimmel and others, Moussawi concludes that in Lebanon, though this is not exclusive to Lebanon, hegemonic masculinity is constructed as a relational performance built on the exclusion of femininity and homosexuality. In this exclusionary practice, homosexuality becomes the threat not just to heterosexuality but to masculinity itself because the dominant culture conflates the two metonymically. Consequently, popular caricatures of male homosexuals often use mockery of stereotypical femininities rather than any actual sexual acts. As Moussawi puts it, "[B]eing mistaken for a homosexual can be viewed as a means of losing one's [masculine] privilege." It wasn't until I moved to the US that I began to realize how much of a mixed bag this was. Rather than trying to disprove that homophobic trope, I think I engaged in what Muñoz calls antisocial queerness, or perhaps the politics of negativity, which embraces the "negative" image that straight life has of gay life. The trope of excluding homosexuality from masculinity is another patriarchal, homophobic technology meant to police gender expression and keep male bodies in line. It nonetheless positioned me so far outside of masculinity the moment I became publicly identifiable as a nonheterosexual that it allowed me to play in the sidelines of gender, affording me a kind of malleability that alleviated or postponed a lot of the questions that I had about my own gender expression.

This trope of trying to find space outside the binary presents itself elsewhere in my work. "Shim El Yasmine" (2009), on the band's first album, lands like any common love song about unrequited love. Most love songs in the Arabic language use masculine pronouns and conjugations when addressing the loved one, whatever the subject's actual gender identity. The song begins to destabilize this tradition in a line where the narrator expresses wanting to have fulfilled the stereotypically "wifely" duties of domestic labor—again engaging in the antisocial affirmation of the narrator's stereotypical femininity, which becomes a point of contention only when the narrator's body is read as being male.

There is a similar logic on a track called "Aoede," the first track on *Ibn el Leil*. It follows in the tradition of the Romantic poets by opening the

album with something of a prayer to a muse. Naturally, there is something profoundly misogynistic about the idea of a female muse waiting around to serve male poets and writers by feeding them inspiration or producing intellectual labor that the male writer then benefits from. At the time, I was processing the trauma of my father's death, which became the well I was constantly drawing from to write the album. My father's spirit became the muse Aoede, who in Greek mythology was the muse of voice and song. This displacement of the muse's gender is hyperlegible in the Arabic lyrics because of the masculine suffixes and conjugations added to all the words.

The last song I would like to get into is "Tayf" (2017), which is the Arabic word for specter or ghost. Tayf was also the name of a club in Beirut that was shuttered in 2013, following an unauthorized police raid launched by the municipality to target the club's clientele, who were mostly gay men and trans women. The law that the Lebanese government has historically used to persecute the LGBTIQ+ community is law 534, introduced during France's colonization of Lebanon. This law is a relic from the Enlightenment era when the word "god" had to be removed from various European legislatures and replaced by the word "nature," which is an equally abstract but secular analogue to "god."

This law criminalizes "all sex against nature," and working with this, the song's opening verse starts with someone describing a kind of ecstatic consumption of the urban environment. The verse intentionally turns the industrial into the natural: bullets and traffic lights become rain and water; neon lights turn into tears; and electricity turns into bone marrow. This anthropomorphizing of the industrial makes a mockery of the double standard of policing sexual behavior through some measure of "nature," or "natural," while every other aspect of our lives is not held to the same standard. The lyric communicates the animalistic eroticism of this urban monster through the vocal delivery, which is unapologetically sensual.

Finally, the chorus of the song makes direct references to the Sylvia Plath poem "Mushrooms." In her writing about women and the movement for gender justice, Plath wrote about mushrooms as these phallic-looking creatures that manage to thrive in the most contemptible conditions, "dieting on water and crumbs of shadow," and yet

multiplying, threatening to inherit the earth. There is a line that I was trying to draw between the two struggles to underscore patriarchy as the common structure that produces misogyny as well as homophobia and transphobia. There are more readily discernible, tangible ways to look at what representation means. From the band's inception, we had been very vocal about our support for the revolutions that were sweeping across the SWANA region. There is something almost quantifiable about what happens when a person in the public eye chooses to own an identity or assume it. This ownership ties that person's struggle to the struggle for justice that other people who subscribe to that identity must also endure. It creates imagined camaraderie for members of those communities who begin to collectivize around a cultural roster of identity-related artifacts that become shared languages.

Metaphor is my most cherished form of representation, or rather nonrepresentation, at times when we are all pushed to make rapid decisions about who we are to make it easier for the world to profile us, to make things knowable, and put things in words.

Something about being on stage with metaphor has allowed me to be a man in a song and then press undo and become something else altogether for the next song. In the eleven years between 2009 and pre-pandemic 2020, my work with Mashrou' Leila allowed me to perform being a housewife, a clubgoer dancing outside of gender, a maenad at a bacchanal, the child of a nonbinary muse, a mushroom, and a genderless urban monster voraciously consuming the city. Metaphor has allowed me to represent myself in language without anchoring myself to anything but the in-between.

طَيْف

غَنِّيتْ مَعْ كُورَسْ أَشْباحْ تَحْتَ رْصاصْ مَدِينْتِي

والدَّبْكَاتْ رْقَصْتَها تَحْتَ ضَوْ إِشَارَةِ السَّيْرْ

لانْتَشِيتْ عَالكَهْرَبا مِنْ نُخَاعِ العَامُودْ

وْصَبَّيْتْ دُمُوعَ النِّيُونْ عَ سَوادْ العُيُونْ

والطَّرَا بِيشّ خُدُونَا، عَالْحُبُوسْ عَشَانْ يُخْصُونَا، وْيَعْمِلُوا الأَوْسَامْ

خَيَّطْنَالُنْ أَعْلامَنا مِنْ أَكْفَانْ جِثَثِ الأَصْحَابْ، اللِي كَانُوا عَالإِعْدَامْ

خِبْزُ الغُرابْ بَدَأْ يِنْبِي مُنَوِّرْثِ الأَرْضِ غَدَّ ايَامَا

خِبْزُ الغُرابْ بَدَأْ يِنْبِي مُنَوِّرْثِ الأَرْضِ غَدَّ ايَامَا

وْقَضَّيْتْ عُمْرِي مَعْ حَقِّي مَرْهُونْ لَأَحاسِيسَكْ آهِ يَا نُوسَكْ

وانْمَحِيتْ مِنْ كُتُبِ التَّارِيخْ كَأَنَّها تارِيخَكْ وَهَوِيتَكْ

بِأَوْراكُنَا تَرْجَمْنَالُنْ أَبْيَاتْ سافُوُ وأَبُو نُوَّاسْ بِلْسَانِ الآهاتْ

عَلَى شَرَاشِفْ طَرَّزْنَاها بِالآهاتِ اللِي نَشَدْناها بِالْمُظَاهَرَاتْ

خِبْزُ الغُرابْ بَدَأْ يِنْبِي مُنَوِّرْثِ الأَرْضِ غَدَّ ايَامَا

خِبْزُ الغُرابْ بَدَأْ يِنْبِي مُنَوِّرْثِ الأَرْضِ غَدَّ ايَامَا

عَلِّيلِي كَعْبَكْ بالْغُنَا بَعْدَها الأَغَانِي مُمْكِنَة

Ghost

Showered with this city's bullets, I chorused with ghosts
Bathed by traffic lights, I danced our dabkeh
Till i was high on the marrow of the electric pole
And i poured tears—neon—on swollen pupils
Till the fezzes came to take us, to prisons, to castrate us, to make
 medallions
But we sewed flags from funeral shrouds (from friends on death row)
The mushrooms have started to grow
Tomorrow we inherit the earth
The mushrooms have started to grow
Tomorrow we inherit the earth
My life spent; with rights mortgaged off to your sentiments
My history erased from our books like they were yours to claim
Our hips translated Sappho and Abu Nuwas in the tongue of oohs
 and aahs
On bed sheets embroidered with the same oohs and aahs we
 chanted at the picket line
The mushrooms have started to grow
Tomorrow we inherit the earth
The mushrooms have started to grow
Tomorrow we inherit the earth
For now we still have songs;
Sing with your highest heels on

Mashrou' Leila, "Tayf" ("Ghost"), *Ibn El Leil* album. 2015. Lyrics by Hamed Sinno.

Q&A

Q

One of the many brilliant things that you did in Mashrou' Leila was create music that touched young generations, some of whom have lost their native language. You did it with spoken language, spoken Arabic, and specifically in a Beiruti accent, which we don't often hear. You also write beautifully in English, as we just heard, and you now live in the United States. Do you currently write lyrics in English or a combination? I wonder if you think about the political implications of the use of language. Your lyrics have helped shift culture in the Arab-speaking world. Do you feel a responsibility toward that audience? Or do you think language comes out of context or out of geography, as is often the case with a lot of us who live across races and languages.

A

I think it's a bit of both. I come from a lower-middle-class family that had access to Lebanese elite education due to the nature of my mother's job. She worked at a university that covered my tuition, and I went to schools that were in gated communities and graduated from high school with a certificate in beginner-level Arabic. On the demos for Mashrou' Leila's first albums, you can hear an American accent, and it wasn't until I got to college that I understood that this is actually a class divide. Frantz Fanon writes about this obsession with cosmopolitanism and "Other" cultures. There was a very conscious effort to dig into Arabic because I did not want to align myself with the Beiruti bourgeoisie and that intelligentsia.

It started with so much thirst. We were going to write music, we were going to change the world, this country [Lebanon] is going to become habitable again, we are going to have our rights, everything is going to be fine. There was a conscious effort to not limit myself to a community. I was nineteen or twenty and very idealistic. I do recognize that there are political implications to that, which can also become dangerous when taken too far. They start to border on various forms of xenophobia that contextually are not the end of the world but still make me uncomfortable. At this point, I live here in the US and I have always pondered the question of whether I should leave. I never wanted to find myself being an immigrant. I never wanted to not be in Beirut. I left originally with the intention of coming here for a bit and going back, but the moment I left, Beirut slammed the door. Right after we got banned, we couldn't go back and play there. I don't know if my name is listed at the airport or not or what kind of investigations are going to happen when I go back. So I am writing in English and not in Arabic. I am writing musicals, which is such an American cultural production, and I am writing musicals for Broadway, which is the ten-year plan: to write very political new musicals.

Thank you so much for an extremely powerful, provocative, and personal presentation. I was really moved by the simultaneous reflection on lyrics, on your personal experiences and on theory, and how you blurred the boundary between all three of these in really productive ways.

You shared with us the place and role of metaphor in the work that you and Mashrou' Leila have done. I'm curious how much of what you're sharing with us was conscious at the time, as opposed to you looking back at yourself and now understanding that that's what was happening. In other words, has your thinking about metaphor changed, so that now you look back and you see some of these dynamics— or was this what you were thinking while creating the music?

Q

A

This answer might start to tread into dangerous territory that sounds kind of New Agey, but I think there's something about producing creative labor that taps into one's subconscious, into that strange loop that creates a subjectivity; and for me, I've always had a resistance to being one thing or another and to gender binaries. This resistance has come out in the music: for example, there was obviously a very conscious decision to constantly switch conjugations in "Kalam," and to refer to Aoide as my male father. These were very conscious decisions to fuck with gender.

I honestly would not have articulated it as a form of resisting "straight meaning" until I read Muñoz's writing on "straight time," which helped me articulate something that I didn't have words for before. I'm not going to pretend I had thought about it that way when I was 20 and was writing these lyrics. But there was an impulse that I felt, and then I found it articulated in

these queer theory texts; they resonated very strongly for me because it was something that I'd always felt in my chest but could not yet put into words.

ABOUT THE EDITOR

Through the Ruins is edited by writer and curator Fawz Kabra, cofounder and director of Brief Histories, an art gallery and publishing platform based in New York. Kabra has served as assistant curator at the Solomon R. Guggenheim Foundation in New York and has curated exhibitions at the Center for Curatorial Studies, Bard College; the Palestinian Museum in Birzeit; BRIC Arts and Media House, Brooklyn; and Art Dubai Projects. Her writing has been published in *Art Papers*, *Canvas*, *Ibraaz*, *Protozine*, and *Ocula*. Kabra earned her MA at the Center for Curatorial Studies at Bard College in 2013.

ABOUT THE CONTRIBUTORS

Ashmina Ranjit is a Nepalese conceptual artist, activist, and the creator of the art hub LASANAA / NexUs.

Border Forensics, cofounded by Charles Heller and Lorenzo Pezzani in 2021, is a research and investigation agency that seeks to document and contest border violence in all its forms.

Cassils is an internationally exhibiting transgender artist who makes their own body the material and protagonist of their performances.

Christian Ayne Crouch is a scholar of the Atlantic world, borderlands, and intercultural exchange, and the dean of Graduate Studies and associate professor of Historical Studies and American and Indigenous studies at Bard College.

Danielle Riou is the associate director of the Human Rights Project at Bard College and the cocreator of the Milosevic Trial Public Archive.

Emilio Rojas is a queer, Latinx immigrant with Indigenous heritage and a multidisciplinary artist working primarily with the body in performance.

Emily Johnson is an artist who makes body-based work. She is of the Yup'ik Nation, and is a land and water protector, an organizer for justice, sovereignty and well-being, and co-lead of First Nations Performing Arts.

Faustin Linyekula is a dancer, choreographer, director, storyteller and the founder of the Studios Kabako, an art and community space in Kisangani, DRC.

Gideon Lester is a creative producer, dramaturg, and curator. He is the artistic director and chief executive of the Fisher Center at Bard and senior curator at the OSUN Center for Human Rights and the Arts.

Hamed Sinno was the writer and front-person for Mashrou' Leila in Beirut and is now a New York–based musician, poet, vocal instructor, and social justice advocate.

Kerry Bystrom is associate dean of the College at Bard College Berlin, associate professor of English and Human Rights, and a lead in the Open Society University Network refugee education programs Hubs for Connected Learning Initiatives and Open Learning Initiatives.

Marcelo Brodsky is an Argentine photographer, visual artist, and human rights activist.

Mark Sealy is a writer, curator, and the director of London-based photographic arts institution Autograph ABP. He is currently the Principal Fellow Decolonising Photography at University of the Arts London.

Sahar Assaf is a Lebanese actor and director, and currently the executive artistic director of Golden Thread Productions in San Francisco, California.

Tania El Khoury is a live artist and the director of the OSUN Center for Human Rights & the Arts at Bard College where she is also distinguished artist in residence in the Theatre & Performance Department.

The White Pube is the collaborative identity of Gabrielle de la Puente and Zarina Muhammad under which they publish reviews and essays about art, video games, and food.

Ziad Abu-Rish is a scholar of the modern Middle East and North Africa region, the director of the MA Program in Human Rights & the Arts, and an associate professor of Human Rights and Middle Eastern Studies at Bard College.